ND 2420 .C722 2005

FEB 2006

JOHN M. MERLO BRANCH 644-48 BELMONT AVE. CHICAGO, ILLINOIS 60357

Watercolor

Alwyn Crawshaw June Crawshaw Trevor Waugh

© HarperCollins Publishers 2005

All rights reserved. No part of this publication may be reproduced, stored in a retrieval system, or transmitted, in any form or by any means, electronic, mechanical, photocopying, recording or otherwise, without the prior written permission of the publishers. For information address HarperCollins Publishers, 77-85 Fulham Palace Road, Hammersmith, London W6 8JB. www.collins.co.uk

ISBN-10: 0-00-719327-0 ISBN-13: 978-0-00-719327-1

WATERCOLOR. All rights reserved. No part of this book may be used or reproduced in any manner whatsoever without written permission except in the case of brief quotations embodied in critical articles and reviews. For information in the United States, address HarperCollins Publishers, 10 East 53rd Street, New York, NY 10022.

www.harpercollins.com

ISBN-10: 0-06-082814-5 (in the United States) ISBN-13: 978-0-06-082814-1

FIRST U.S. EDITION

HarperCollins books may be purchased for educational, business, or sales promotional use. For information in the United States, please write to: Special Markets Department, HarperCollins Publishers, 10 East 53rd Street, New York, NY 10022.

The name of the "Smithsonian," "Smithsonian Institution," and the sunburst logo are registered trademarks of the Smithsonian Institution.

Text and illustrations @ Alwyn Crawshaw, June Crawshaw, and Trevor Waugh, 2004

Alwyn Crawshaw, June Crawshaw, and Trevor Waugh assert the moral right to be identified as the authors of this work.

Printed and bound by Printing Express Ltd, Hong Kong

10 09 08 07 06 05 9 8 7 6 5 4 3 2 1

contents

The authors	6
materials & techniques	8
painting landscapes	26
painting the seashore	78
painting flowers	126
Need to know more?	190
Index	191

JOHN M. MERLO BRANCH 644-48 BELMONT AVE. CHICAGO, ILLINOIS 60657

The authors

Alwyn Crawshaw

Alwyn Crawshaw has inspired millions of amateur painters and has made seven popular television series on painting, which have been shown worldwide. He has made many successful videos on painting and is the author of over 20 books on art instruction, all of which are published by HarperCollins. A regular contributor to British-based Leisure Painter magazine, Alwyn is Founder of the Society of Amateur Artists, President of the National Acrylic Painters Association, a member of the Society of Equestrian Artists and the British Watercolor Society, a Fellow of the Royal Society of Arts, and an Honorary member of the United Society of Artists. He is listed in the current edition of Who's Who in Art, and the Marquis Who's Who in the World.

June Crawshaw

June Crawshaw paints in watercolor, acrylic, and oil. She is a member of the Society of Women Artists, the British Watercolor Society, the National Acrylic Painters Association, and is an Honorary member of the United Society of Artists. She had major joint exhibitions with her husband Alwyn in Tokyo in 1998 and 2001, and in 1992 she helped him to found and launch the Society of Amateur Artists. June writes articles for Leisure Painter magazine and has featured in three television series with Alwyn, which have been screened worldwide. She has her work published as fine art prints and greetings cards. Her first book was published by Collins in 1995. She is listed in the current edition of Who's Who in Art.

Trevor Waugh

Trevor Waugh studied at the Slade School of Fine Art in London and is now an established popular painter who runs successful painting workshops and vacations. In recent years, he has traveled extensively throughout the United States, the Middle East, Morocco, Egypt, France, Italy, Spain, and Turkey, painting, running watercolor classes, and exhibiting his work. Apart from his original watercolors and oils. Trevor's work is also known to a wide market through his greeting cards, prints, and other merchandise. Visit his website at http://www.trevorwaugh.com. His other books, also published by HarperCollins, are Winning with Watercolour, which has become a top-selling title, and You Can Paint Animals in Watercolour.

materials &

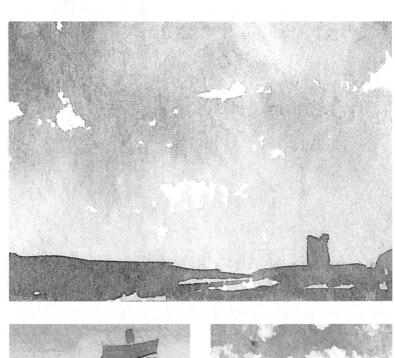

techniques

Before you start painting in watercolor, you will need some basic art materials and a wide range is now available. You can add different brushes, colors, and paper as you gain experience. You will also need to learn and practice a variety of techniques in order for you to understand how your materials behave and how to create different paint effects.

Basic materials

There is nothing special about the watercolor materials you need for painting. The ones recommended here can be used for any subject, and, as a beginner, you don't need to buy a whole range of expensive art materials. In fact, the fewer you have, the less you have to learn to use.

Colors

Watercolors come in pans or tubes. Pans are better for beginners because you can control the amount of paint you put on your brush more easily. There are two qualities of paint: Students' and

Artists'. Artists' quality are best but Daler-Rowney Students' Georgian are good and less expensive.

The following colors are ideal for painting landscapes or seascapes: Alizarin Crimson, Yellow Ocher, Cadmium Yellow Pale, Cadmium Red, French Ultramarine, Hooker's Green Dark, and, occasionally, Ceruleum blue. For painting flowers, you will need Naples Yellow,

Lemon Yellow, Cadmium Yellow, Gamboge, Indian

Yellow, Cadmium Orange,

▲ Watercolors come in tubes or pans.

Vermilion, Permanent Rose, Permanent Mauve, Phthalo Blue, Cobalt Blue, Phthalo Green, Raw Sienna, Burnt Sienna, and a watercolor white.

Brushes

The best watercolor brush to buy is a sable hair brush. These are made from real sable fur, so they are also the most expensive. There are also excellent synthetic brushes on the market that cost much less than sable (for example, Daler-Rowney's Dalon), and some synthetic-sable mix ones. For landscapes and seascapes, use a No. 10 for your big brush, a No. 6 as your small brush, and a D99 rigger No. 2 for thin lines. The higher the number, the larger the brush, and for flowers you will also need No. 8, No. 14, and No. 20 brushes. All round brushes should come to a good tip when wet.

Paper

There are many different makes of paper available in different weights and textures. In this book, the papers usually used are Bockingford watercolor Cold Press paper (this means it has some texture although it is not rough), and sketching paper. Both are inexpensive and of excellent quality and can be bought in pads of different sizes. Even experienced artists can find it aweinspiring to sit, brush poised, in front of a large, blank piece of paper. When you are starting, don't do any paintings larger than 10 x 15 inches (25 x 38 cm), although it is not helpful to work in "miniature" either, because you will not get the feel for the movement of the paint and the brush on the paper. Finally, when watercolor painting you must always have your paper at

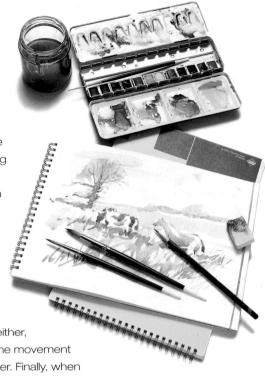

▲ Basic equipment for a beginner.

Other equipment

A 2B pencil is good for drawing because it is soft, but you may also want to use an HB and 4B to give varying degrees of softness in sketching. A kneadable eraser is useful for erasing because it can be used gently without causing too much damage to the paper. A craft knife is essential for sharpening your pencil. You will also need a water container—an empty jam jar is ideal. Although you will normally mix your colors in the palettes in the lid of your paintbox, you will also need a separate mixing palette or a white china plate for larger washes.

an angle to allow the paint to run slowly down the page.

You can do this by taping it to a sloping drawing board.

MUST KNOW

Practice indoors

Finally, it is a good idea to get used to working with your materials before you venture outside. This will make painting landscapes outdoors much more enjoyable.

Techniques

As a beginner, it is important to practice some basic techniques with your different materials before you try painting. These will help you to understand how your pencil, paints, brushes, and paper behave. There are many ways to create different paint effects, and with practice you will be able to find some different ones of your own.

Using a pencil

Your landscape paintings start with a drawing, so it is important to get used to using a pencil. Also, you will sometimes find that you only have a pencil with you on location, so it is important to feel confident that you can get the most out of a pencil sketch to make it easy to use when you paint from it at home.

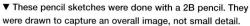

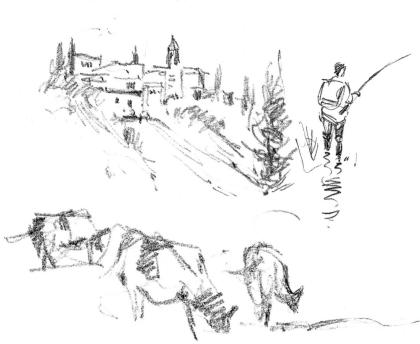

Using a pencil takes practice, but you will soon get the feel for it. Use ordinary photocopying paper to practice, because it's inexpensive and you can "scribble" as much as you want. The most important rule is to sharpen your pencil correctly. The pencil was sharpened to a long point for drawing this page and not sharpened again, and the ovals drawn in thin lines at the bottom were done last of all!

▲ This pencil has a long point. This makes it versatile. As you work, the point wears off and creates a "chisel point" (below). This allows you to make thick lines for shading.

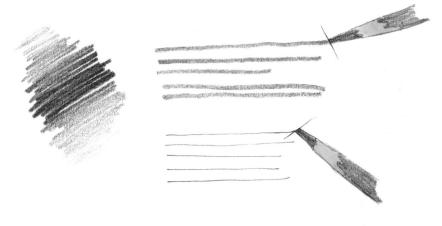

▼ If you want a thin line with your chisel point, turn the pencil half around in your hand and draw with the end of the edge of the chisel (above). By using a pencil in this way you can use thick and thin lines throughout a pencil sketch.

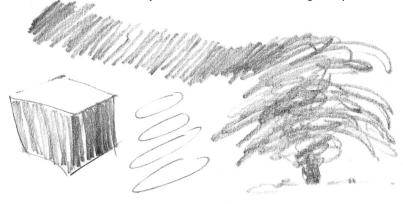

Discover Watercolor

Brushstrokes

Use your brushes to produce a variety of different strokes. The way you use them gives the painting your own identity, in the same way that when you use a pen for writing it makes your writing individual. With practice, you will soon find your brushwork becoming second nature. Below, a small brush is used for the green strokes and a rigger for the blue lines.

▶ Paint some thin lines by applying no pressure to the brush. Then try a thicker brushstroke by loading the brush with paint, working up to a drawn line at the top edge, and filling in with paint below.

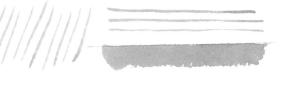

◆ Do two strokes from top to bottom, starting the first without any pressure and then increasing the pressure toward the bottom of the stroke. Start the other with pressure, then gradually ease off.

► This was painted with watery paint, which ran to the bottom making puddles. If allowed to dry, these can make an unwanted dark area. Avoid this by soaking the excess paint up with a damp brush before it dries.

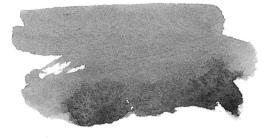

▲ Try painting some fine lines using your rigger brush. You will find this brush invaluable for painting thin tree branches and for any other fine line work.

Dry brush

The "dry-brush" technique is used in almost every watercolor. As a natural brushstroke starts to run out of paint, the paint hits and misses the paper and leaves flecks unpainted. This effect can be achieved where you want it either by using less paint on your brush or by pushing the brush hairs down at the ferrule end (the metal end that holds the hairs) while you paint.

▲ The rougher the paper surface, the more exaggerated the dry-brush effect.

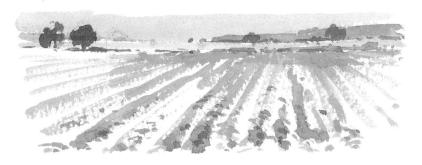

▲ A plowed field painted using this technique.

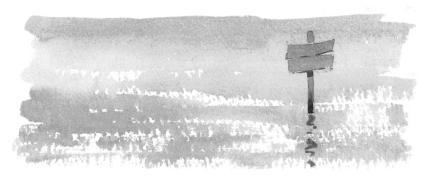

▲ The dry-brush effect is the ideal technique for showing sparkling sunlit water.

1

Washes

If you are now familiar with your brushes, the next stage is to practice making some washes. The wash is the most fundamental technique in watercolor painting. Remember to always keep your paper at an angle to allow the paint to run downward naturally.

▲ Flat wash

Load a brush with plenty of watery paint and make a definite stroke across the top of the

paper. Lift the brush off, fill with paint, and take the next stroke across, letting it run and mix with the one above. Continue.

▲ Graded wash

Paint this in the same way as the flat wash, but as you work down add water to the paint in the palette to dilute the color; repeat this process with each brushstroke.

▲ Color graded wash

Work the same way as the graded wash, but instead of water add different colors into your palette as you work down. This is a great way to paint a sunset.

Wet-in-wet

In the exciting wet-in-wet technique, when a wet color is put on top of another wet color, the colors merge and mix together. This creates "happy accidents"—areas where you do not control the results, but which look great. With experience, you'll learn to create and control happy accidents.

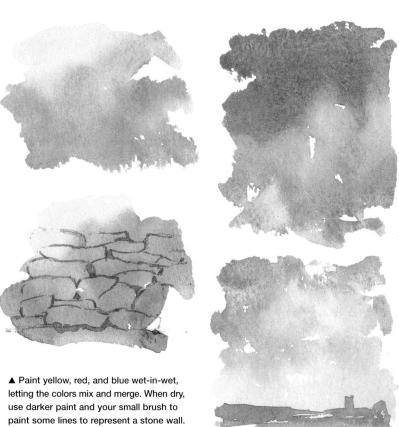

▲ Use the same color mix as before, but with blue as your main color. When dry, suggest the simple silhouette of hills and a church. Wet-in-wet is great for painting skies.

Discover Watercolor

Wet-on-dry

When you paint wet paint onto dry paint you will always get a hard edge. The paint must be totally dry, or the wet paint will merge into the damp color, creating a blurred edge.

Soft edges

Making soft edges is as important as hard edges, and you will use this technique throughout a painting.

A soft edge can be achieved in several different ways.

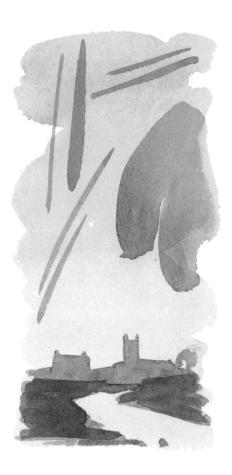

▲ Paint a color wash and allow it dry. Then paint shapes and brushstrokes over it. To paint thin lines, use less water in your brush, or the paint will spread.

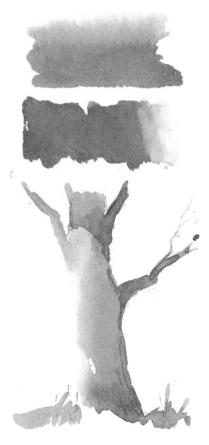

▲ Start painting with water first and then add color. Or add water at the end of an area of color. Also try lifting for a soft edge (see opposite), as for the tree trunk here.

Lifting

Removing an area of paint is known as lifting. You can use this technique to correct mistakes, or use it deliberately to lighten a darker area of the painting. You can lift paint better on some papers than others. There will usually be a slight stain left on the paper, depending on the color of the paint. You can lift paint using tissue or a brush.

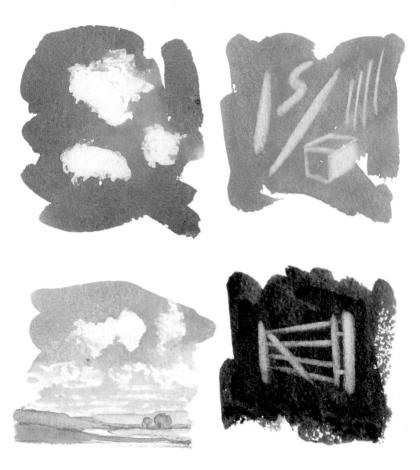

▲ Paint an area of blue and, while it is still wet, press a scrunched-up soft tissue onto it to lift off the paint to represent clouds. This is a simple technique, but impressive.

▲ A brush gives more control over the area to be lifted. After the paint dries, brush water over the area and blot with tissue. You may have to repeat this a few times.

Easy color mixing

When looking at a painting you can see hundreds of different colors. However, don't worry; these can be simplified. For example, the predominant landscape colors are blues (in the sky), greens (fields and trees), and browns (earth colors). All colors can be mixed using just three primary colors: red, yellow, and blue. Different shades of red, yellow, and blue mix to create a wide range of different colors.

Starter palette

Begin with the colors below in your starter palette. Yellow Ocher, Alizarin Crimson, and French Ultramarine are useful primary colors as are Cadmium Yellow Pale, Cadmium Red, and Ceruleum. For landscapes, one "mixed" color, Hooker's Green Dark, is useful because different primary colors may be added to it to make different greens. To make colors lighter, add water; to make them darker, add less water or more paint (pigment).

Basic starter palette

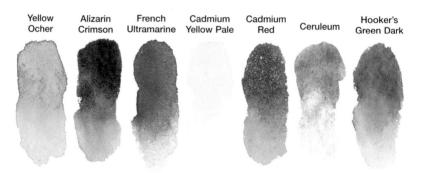

MUST KNOW

The golden rule

The most important rule to remember when mixing colors is to put the predominant color into your palette first (with water), then add the other colors to it, usually in smaller amounts. For example, if you wanted to mix a yellowy green, put yellow into your palette, then add smaller amounts of blue until you reach your desired color.

Practice color mixing

Below, left, are two examples of mixing greens—one a yellowy green, the other a dark blue-green—showing how the predominant color is used first. Below, right, two different sets of primary colors have been mixed to show the range of colors you can create by mixing different yellows, reds, and blues. With practice, you will be amazed at what you can achieve with color mixing. You will find it easier than you expect—and enjoyable.

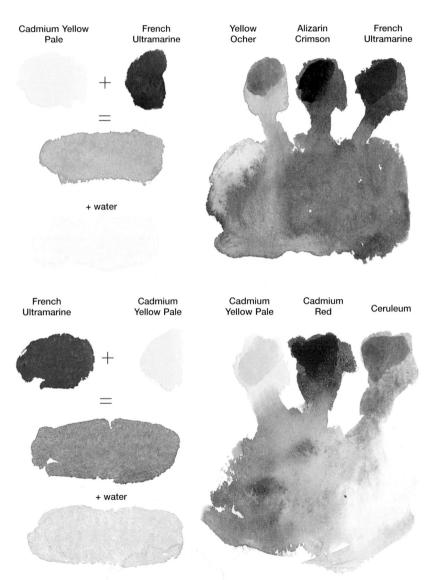

Discover Watercolor

Mixing landscape greens

Here are some of the different greens that can be mixed from your starter palette. Add the second color gradually to make the mixed color darker.

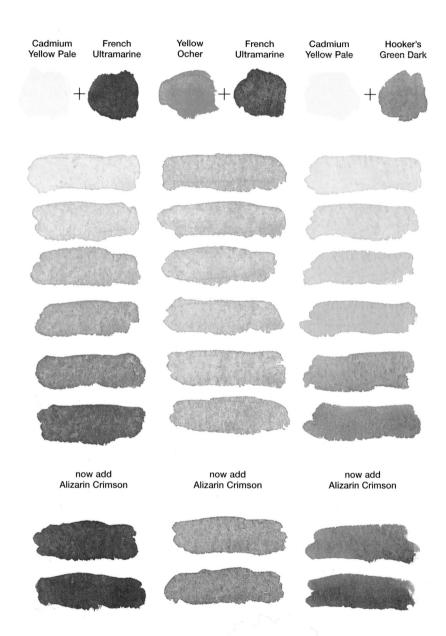

Like the greens, you can mix a wide variety of browns from just a few colors. Add the second color gradually to make the mixed color darker.

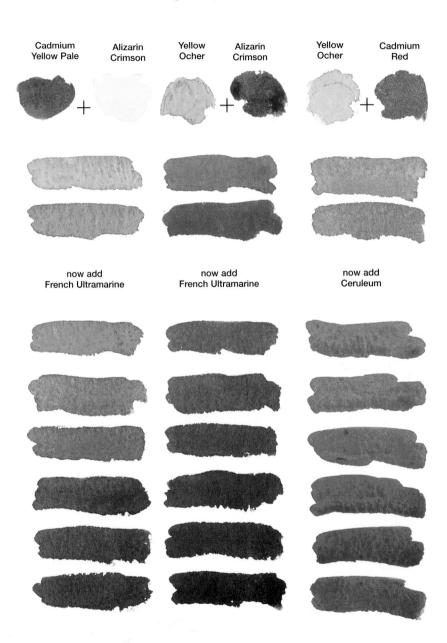

Making objects look 3-D

The only way in which you can make an object appear real and three-dimensional, not just flat, is to add shadows. Look at the boxes below and the objects on the opposite page. They become real objects only by adding shadows to the flat shapes. Light against dark will always show shape and form and make objects look three-dimensional.

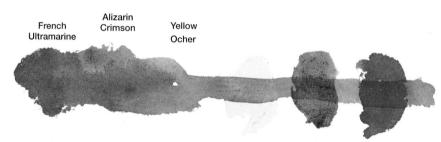

▲ Mix French Ultramarine, Alizarin Crimson, and a little Yellow Ocher for a general shadow color. Because watercolor is transparent.

when you paint this shadow color over a dry color, the color will show through, but it will appear darker, giving the illusion of a shadow.

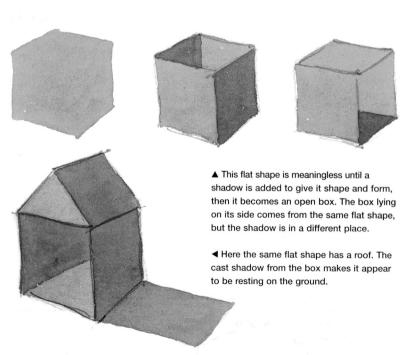

24

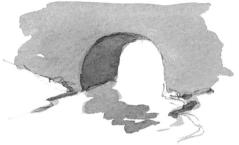

▲ This bridge looks flat (top) before the shadow is painted as shown above.

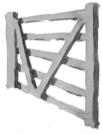

▲ With only a few dark shadow lines, the gate looks three-dimensional.

want to know more?

Take it to the next level...

Go to...

► Techniques: page 80

► Using your brush: page 128

▶ Using color: page 136

Other sources

► Art stores

try different materials

▶ Art classes

many colleges offer painting courses

▶ Specialized magazines

The Artist's Magazine, American Artist, and American Artist Watercolor

▶ Publications

visit <u>www.harpercollins.com</u> for HarperCollins art books

▲ Notice how the shadow on the tree stump has been given a soft edge to make it appear rounded. Remember to wait until the first wash is dry before you start painting any hard-edge shadows.

painting

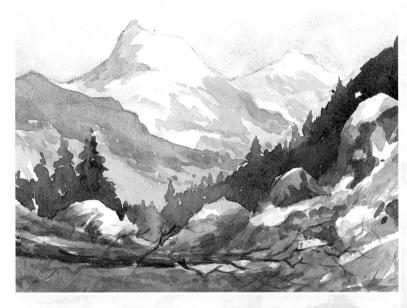

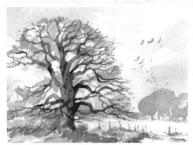

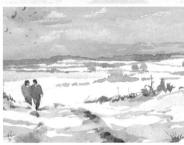

landscapes

Landscape is everywhere you look, and it is perhaps the most popular subject for artists. For a beginner, just looking at a view of a complex landscape can be daunting, but remember the old adage, "don't run before you can walk." By following the expert advice in this section, you will soon progress and will be painting good landscapes sooner than you think.

Skies

The sky is the most important part of a landscape painting because it sets the mood. If you reflect the mood of the sky in the rest of your painting, you will give the whole painting atmosphere. When practicing skies, adding land, however simple, will help to give scale to the sky.

Heavy sky

Notice how clouds get smaller and narrower as they go to the horizon. This gives the illusion of distance. Remember the "happy accidents" you get when working wet-in-wet. Skies with clouds are full of them!

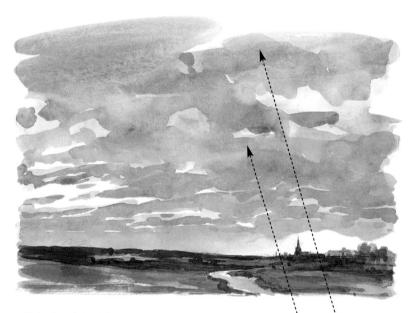

▲ Paint the whole of the sky and into the landscape in one wash, wet-inwet, changing the colors as you work. When this is dry, paint a darker wash to give more shape to the clouds, using water to soften the cloud edges and allowing some colors to merge. Then paint in the landscape, keeping it simple and reflecting the mood of the sky in the colors.

Hooker's Green Dark + Yellow Ocher + Alizarin Crimson + French Ultramarine

Skies in pencil

Copy skies from life, using a 2B pencil. You will not be concerned about color, so all your concentration will be on the formation of clouds and their different tones. Even white clouds have shape and form, and shades of dark against light.

► Practice using your pencil flat to get a broad shading line. This will help you to draw and shade the clouds more quickly sometimes they can move fast!

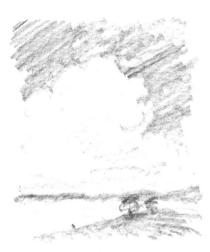

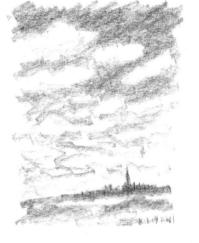

▲ This cloud formation was moving slowly and, therefore, speed was not of the essence. The "blue" sky was given a dark shade to create a contrast in the clouds.

▲ These clouds were moving fast, so try to catch the general impression, not each individual cloud shape. Note how they get smaller toward the horizon.

à

Discover Watercolor

One-wash sky

This is a simple sky painted with only one wash, wet-in-wet. Use a large brush for the sky and the simple landscape. Notice how the dark shadow of the clouds has run into the blue sky and given the impression of a rain shower. This was a controlled "happy accident."

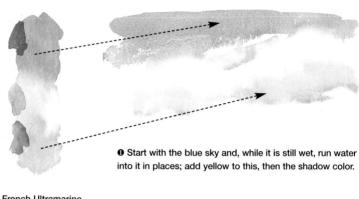

- + Yellow Ocher + Alizarin Crimson
- Paint the distant blue sky and allow it to run into the bottom of the clouds. Notice how the shadow of the cloud gets lighter as the paint runs into the blue sky. Finally, when the sky is dry, paint the landscape.

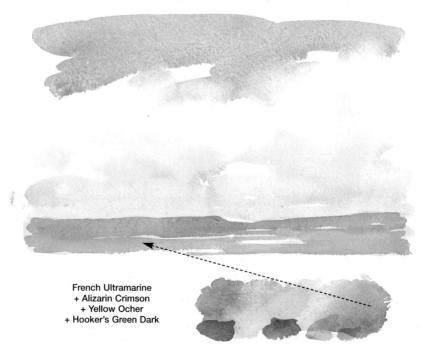

Sunset

You must be careful when you paint a colorful sunset. Sunsets look fantastic in real life and inspiring, but as a painting they can look overdone and too colorful. Therefore, until you have gained experience in painting with watercolor, tone down the colors.

• Using your big brush, paint a graded color wash down from the sky into the landscape.

French Ultramarine + Yellow Ocher + Alizarin Crimson

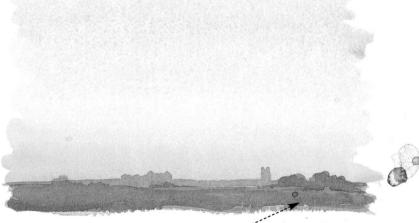

❷ When the wash is dry, paint in the landscape. The warm colors of the underpainting (the sky) help to give the ground colors an evening atmosphere.

Yellow Ocher + Alizarin Crimson + French Ultramarine

Discover Watercolor

Stormy sky

This stormy sky looks complicated, but it is painted in the same way as the other skies, wet-in-wet, just using stronger colors. There are "happy accidents," both controlled and uncontrolled. Because you are painting wet-in-wet, your painting will not look exactly the same as this.

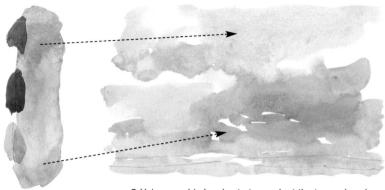

French Ultramarine + Alizarin Crimson

- + Yellow Ocher

• Using your big brush, start a wash at the top and work down the sky, changing your colors as you paint. Keep the paint watery so the colors can merge together. Paint into the landscape and allow it to dry.

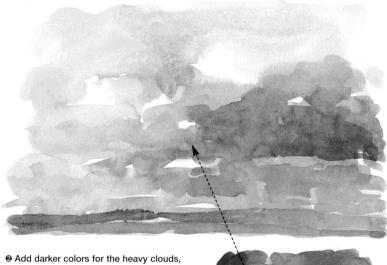

then paint the landscape. Using only water, gently brush out the sky and landscape under the "black" cloud to give the illusion of rain.

Yellow Ocher + Alizarin Crimson + French Ultramarine

Sunny day

For this sky, I used the lifting-out technique shown on page 19 to indicate the clouds. The impression of a sunny day was helped by adding shadows on the landscape, which are being cast from the clouds onto the grass.

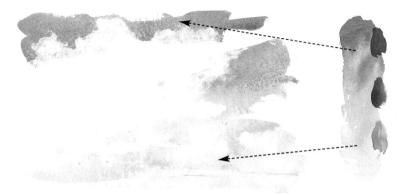

• Paint the blue sky first, leaving some white unpainted paper, then change the colors as you paint down to the landscape. Blot out the clouds with scrunched-up tissue.

French Ultramarine + Alizarin Crimson + Yellow Ocher

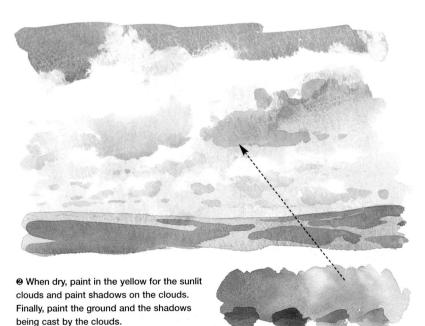

French Ultramarine + Alizarin Crimson

+ Yellow Ocher + Hooker's Green Dark

EXERCISE

Paint a sky

In this exercise, the clouds are painted with one wash using the wet-in-wet technique. The crisp, hard edges are created by leaving white paper.

Because you are painting wet-in-wet, your finished painting will look different from the one shown here—use this painting as a guide.

The palette

Ultramarine

Alizarin Crimson

Hooker's Green Dark

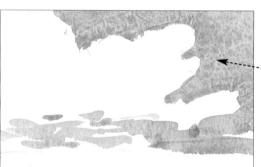

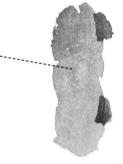

French Ultramarine + Alizarin Crimson

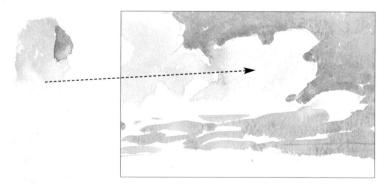

Yellow Ocher

Now paint the yellow sunlit areas of the clouds, allowing the yellow to touch the blue sky in places.

While the yellow is still wet, paint the shadows onto the clouds (wet-in-wet).

French Ultramarine + Alizarin Crimson + Yellow Ocher

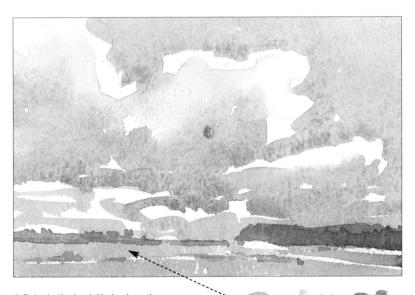

Paint in the land. Notice how the white unpainted paper stands out after the land is painted. This makes the sunlit areas sparkle.

Hooker's Green Dark + Yellow Ocher + Alizarin Crimson + French Ultramarine

Most landscapes are dull without trees. Like the sky, they have an important role in your paintings. No matter how simple the sky and background, if the trees look plausible, the painting will be good. Some trees (fir, poplar, and cypress) are easy to paint; others, such as an oak, are not. However, with practice, your confidence and ability will grow.

Hedgerow trees

Look at the simple background to this tree painting. The distant trees on the right are just silhouettes and the sky is a simple wash. However, because the trees in the foreground have more detail, they stand out from the background, giving space to the landscape.

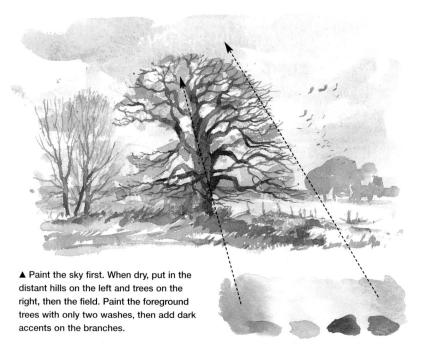

Hooker's Green Dark + Yellow Ocher + Alizarin Crimson + French Ultramarine

Winter tree in watercolor

When you paint the branches on a tree, always paint the brushstrokes in the direction the tree is growing. Don't draw in the small, feathery branches because these are usually worked with a wash or dry brush.

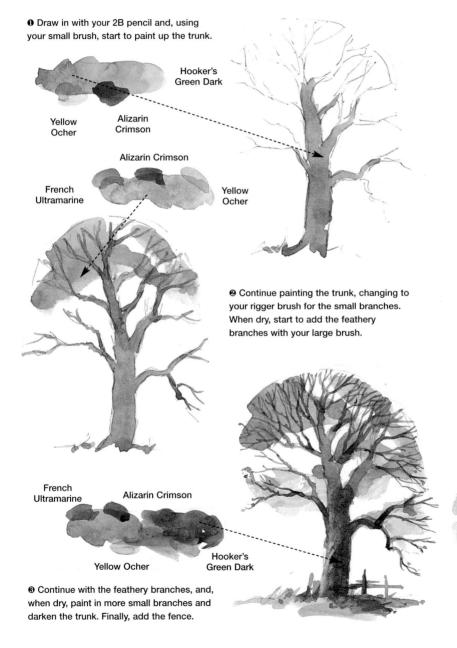

Summer tree in watercolor

When you are painting from life, be aware of the scale of the tree. Painting a tree the same size as the one on this page, an individual leaf would be smaller than a period, so any "blobs"

that you paint are not individual leaves, but bunches of leaves.

• Draw the tree with your 2B pencil. Start painting by working up the trunk, using your small brush.

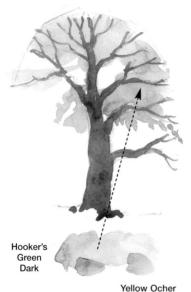

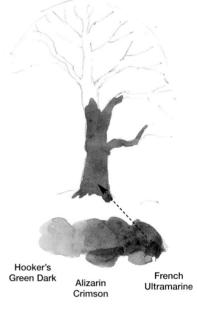

Ocntinue and paint in the smaller branches. When this is dry, start at the top and paint the foliage over the branches.

O Continue with the foliage. When dry, paint the darker areas. Lift out the trunk in the middle of the tree to let the foliage take its place. This helps the tree to look three-dimensional. Don't forget the fence-it adds scale!

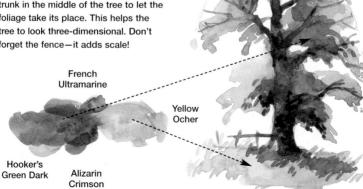

Nothing beats the fall colors of deciduous trees. However, like a sunset, fall colors can look overdone in a painting, so be careful. There are usually some green leaves left on some trees,

which will help to avoid too many bright colors, and you can add evergreen trees to your painting.

1 Draw the tree with your 2B pencil. Then paint it using your small brush.

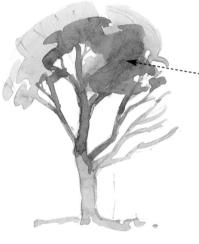

Alizarin Crimson

Yellow Ocher

Start at the top and add the darker foliage colors and continue down the trunk.

Yellow Ocher

Alizarin Crimson

French Ultramarine

9 Finish painting in the dark foliage color and then paint the trunk and branches darker. Add some new darker branches at the bottom, some shadows, and the fence.

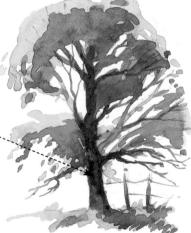

Sketching trees

If you are a little nervous about going out to sketch from life, then first copy the sketches on these pages. They will give you the confidence to sit and sketch outdoors. They were painted simply, using simple brushstroke washes and adding some details with a rigger brush.

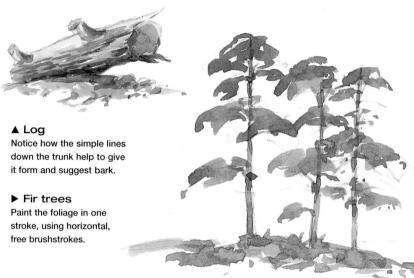

▼ Apple tree

It is important to observe and draw the branches, showing sunlight and shadows.

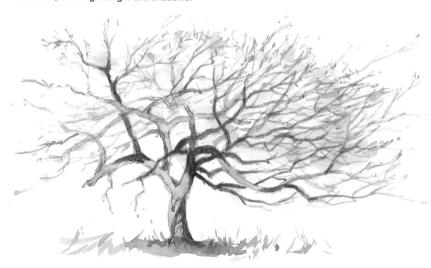

▲ Poplar trees

Like the fir trees, use simple brushstrokes, but this time paint them downward.

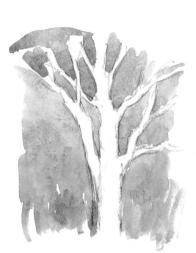

▲ "Light against dark" tree

It is sometimes necessary to show a tree light against dark, effectively "reversed out." This technique needs practice.

The tree looks more complicated because of the small thin branches. These are done with a rigger brush, just as if drawing with a pencil, but the paint must be watery for it to flow easily.

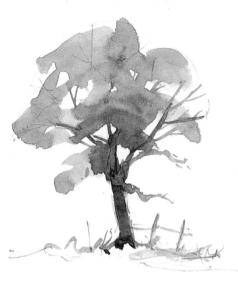

▲ Summer tree

Use the same brushstrokes used for the fir trees, but make them bolder and let them run together in places.

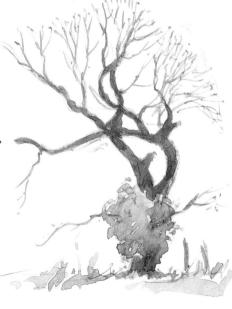

EXERCISE

Paint trees in the fall

Paint these two trees in the same way that you have been practicing on the previous pages. Perhaps the tree with the fall colors should no longer have leaves; however, with the green grass and the dark tree, it makes a pleasant painting. Don't forget that you can use artistic license!

The palette

Hooker's Green Dark

Alizarin Crimson

French Ultramarine

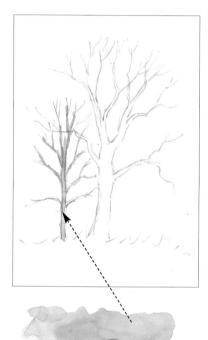

Alizarin Crimson

• Draw the trees with a 2B pencil, then paint in the trunk and branches of the tree with fall color using your rigger.

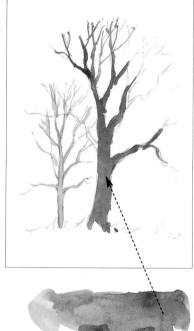

Hooker's Green Dark

Alizarin Crimson

French Ultramarine

② Using the same brush, paint the large tree, working the trunk upward, then adding the thin branches.

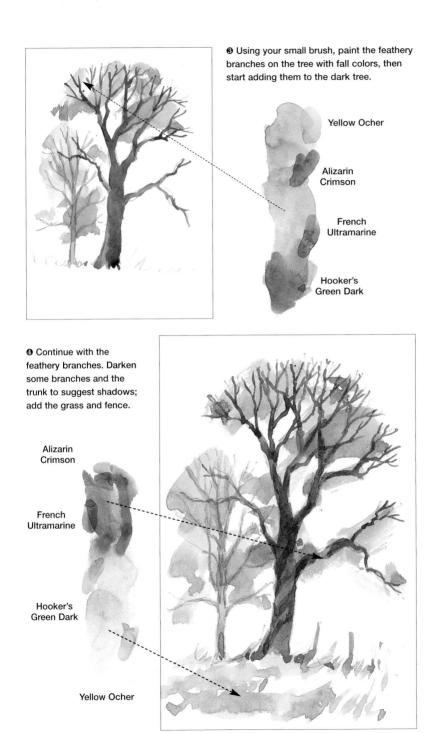

Creating distance

Follow nature's rules to create the illusion of distance in a painting. First, everything is smaller as it gets further away. Second, you see more detail the nearer the object is to you. Third, cool or cold colors (blues) recede into the distance, while warm colors (reds) advance. Fourth, perspective or directional lines help to give the impression of distance. Finally, making objects "misty" or paler helps to imply distance.

Distant landscape

Study the painting below and you can see these "rules" being applied. Next time you are in the countryside check them against what you see. It will surprise you, for instance, how green a close-up field is compared to a field or hills in the distance, which appear blue-green or even just blue. In a painting, you can exaggerate these rules to make distance more obvious.

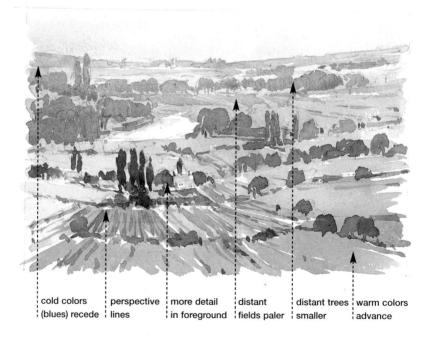

This simplified example shows how cool colors (blues) recede and give the illusion of distance. It also shows how colors become paler the farther away they are. The warm-colored field in the foreground adds to the illusion.

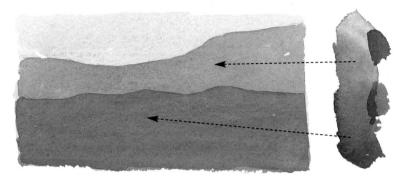

• Paint a pale blue wash down to the field. When dry, paint over the distant and nearer hills with a slightly darker wash. Then paint an even darker blue wash over the last one to show the nearer hills.

French Ultramarine + Alizarin Crimson

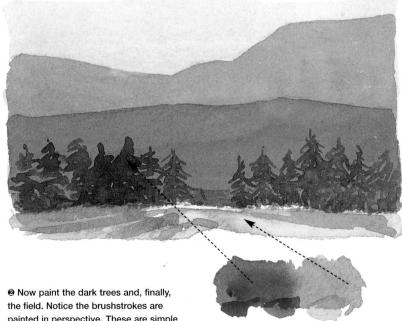

painted in perspective. These are simple techniques, but they all help to give the illusion of distance.

French Ultramarine + Alizarin Crimson + Yellow Ocher

Misty landscape

One easy way to show distance in a painting is to create a misty landscape. Paler colors in the distance help, but here one of nature's weather conditions—mist—is assisting too. Add a path to the painting—it will lead you into the picture and take your eye into the distance.

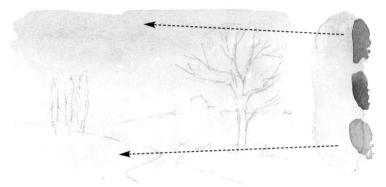

 $\pmb{\theta}$ First draw the scene with a 2B pencil. Paint a graded color wash over the painting, but leave the path unpainted.

French Ultramarine
+ Alizarin Crimson
+ Yellow Ocher

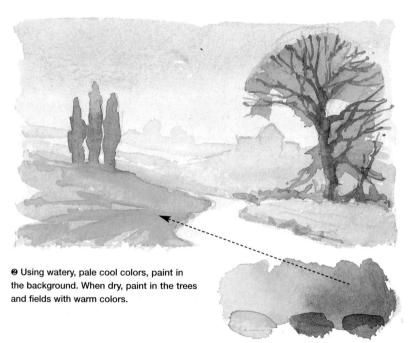

Yellow Ocher + Alizarin Crimson + French Ultramarine

Although this painting includes brightly colored sunny fields, the feeling of distance has still been achieved. The distant hills are dark blue, the silhouette of the church paler blue. The clouds become smaller as they near the horizon. Finally, the road leads your eye toward the distant village.

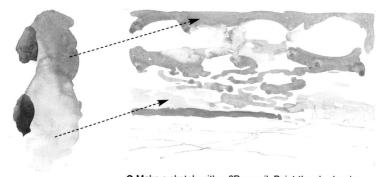

French Ultramarine + Alizarin Crimson

• Make a sketch with a 2B pencil. Paint the sky, leaving unpainted areas for clouds and making them progressively smaller toward the horizon. Paint in the background hills.

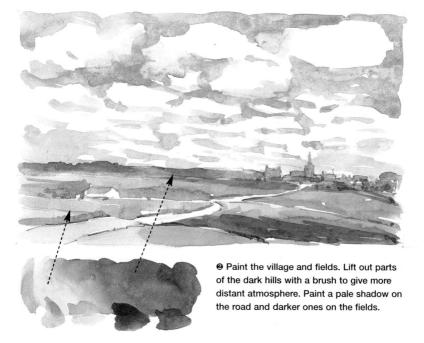

Hooker's Green Dark + Yellow Ocher + Alizarin Crimson + French Ultramarine

4

Foreground path

In a painting, you can make the foreground look closer by the way you paint the distance. In this picture, the blue trees in the distance help the warmer colored foreground appear closer. Always remember that cold colors will make objects recede, warm colors advance.

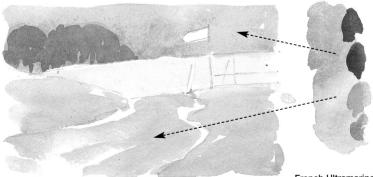

• Paint a wash for the sky, then the green fields and path. When dry, paint in the distant trees.

French Ultramarine + Alizarin Crimson + Yellow Ocher

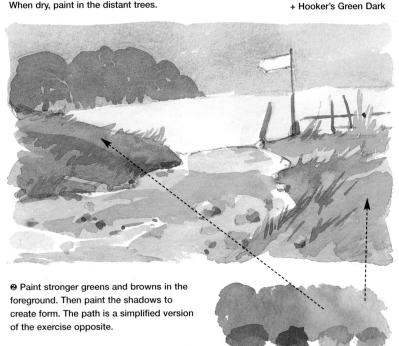

French Ultramarine + Alizarin Crimson + Yellow Ocher + Hooker's Green Dark

Dirt trail

The directional line running from the long grass leads you to the distant trees, which adds scale to the painting and to the foreground. The long grass provides scale for the clumps of earth and stones. As when you paint trees, your foreground should include something to show scale.

• Paint the sky with a wash. Using wet-in-wet and dry-brush techniques, paint in the underpainting. It is important to paint the brushstrokes in the direction of the contours of the land.

French Ultramarine
+ Alizarin Crimson
+ Yellow Ocher
+ Hooker's Green Dark

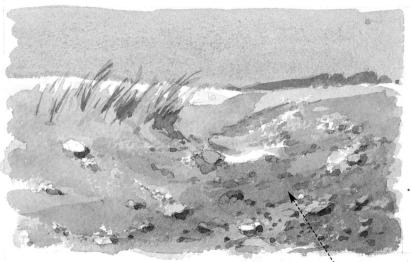

Paint darker areas to give form to the land, leaving lighter areas showing. Paint the shadows to create clumps of earth and stones. Define some stones with a 2B pencil.

Yellow Ocher + Hooker's Green Dark + French Ultramarine + Alizarin Crimson

Water

The biggest mistake beginners make when they start to paint water is to overpaint it. The more you overpaint, the less realistic it becomes. The key is to keep it simple. Once you can paint realistic water, no matter how simple, people will stop and look twice at your painting, so it is worth practicing.

The old windmill

windmill with a soft edge.

Here the water reflects the sky color. The dark reflection of the windmill contrasts with the white reflection of the sail. Paint reflections with the same movement as the water. If the water is still, the reflection will be mirrorlike. If the water has movement, the reflections will be broken by the movement.

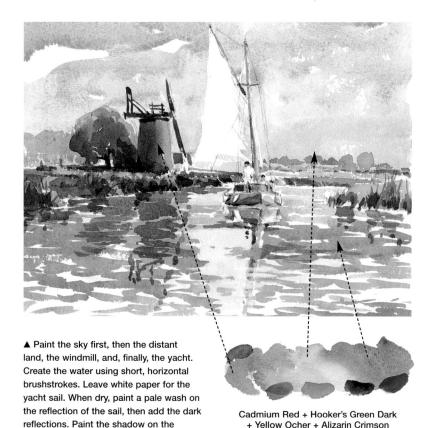

+ French Ultramarine

Reflections

One of the most convincing ways to paint water is to show a reflection. If for any reason there isn't a reflection on the water you are painting, or the reflection is small, then put one in or exaggerate the small one. Use your artistic license. However, above all, keep it simple.

▲ Keep your water and reflections simple. These are simple, but they work.

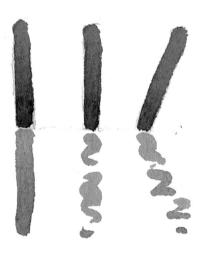

▲ Look at these three posts. The first one has a reflection in still water. The second is reflected in moving water. The third is also in moving water; note how the reflection is at the opposite angle to the post. The water is left as unpainted paper—there is no other visual reference to water and yet the reflections make it look like water.

MUST KNOW

Reflections

As a general rule, remember that all pale objects reflect a little darker than the object, and dark objects reflect a little lighter.

Moving water

Moving water in a river, or where it has been disturbed by the wind or boat traffic, is extremely easy to create in watercolor and will always look impressive. Notice how the light catches the top of the ripples of water, thereby creating the feeling of movement.

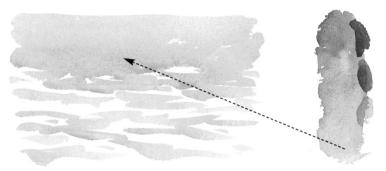

• Paint a wash from the top, then continue using broken horizontal brushstrokes, leaving white paper for the reflected areas of light.

French Ultramarine + Alizarin Crimson + Yellow Ocher

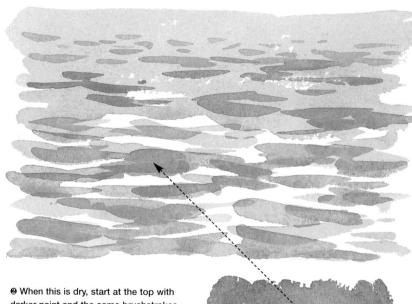

When this is dry, start at the top with darker paint and the same brushstrokes, making them larger as you work down. It is still important to leave some unpainted paper to show reflected light.

French Ultramarine + Alizarin Crimson + Yellow Ocher

Estuary

This is a perfect example of how water painted extremely simply can be effective. Leave the water as white paper until you have painted the surrounding land areas. Then paint various subtle colors on the areas of white paper and add some reflections—the final touches for the water.

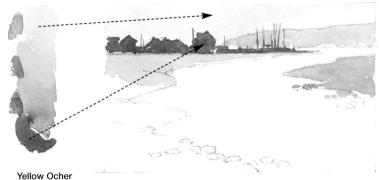

- + Alizarin Crimson + French Ultramarine
- $\pmb{\theta}$ Paint the sky to the top of the mudflats. When dry, paint the silhouette of the headland and the buildings.

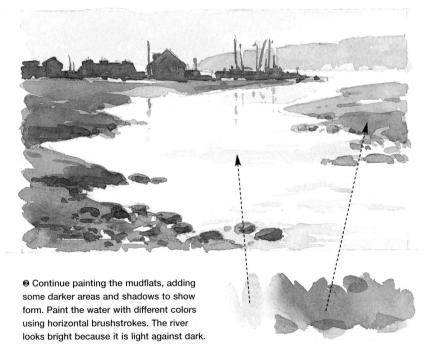

French Ultramarine + Hooker's Green Dark + Alizarin Crimson + Yellow Ocher

EXERCISE

Paint reflections

This exercise shows some typical reflections in moving water. When painting moving water from nature, reflections can be difficult to define. Half close your eyes, concentrate just on the reflections, and you will begin to see their general shapes. Don't let your eyes move with the flow of the water.

The palette

French Ultramarine

Alizarin Crimson

Yellow Hooker's Ocher Green Dark

• Draw the tree and fence with your 2B pencil. Now paint in the sky, using your large brush.

French Ultramarine + Alizarin Crimson

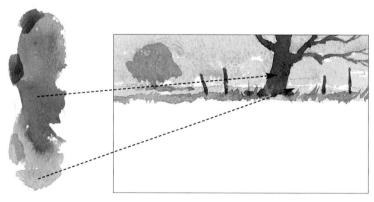

- Hooker's Green Dark + Alizarin Crimson
 - + Yellow Ocher
- Paint in the grass and the distant tree. Now paint the fence and large tree, and add the shadows.

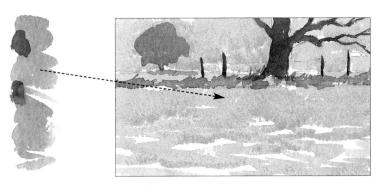

French Ultramarine + Alizarin Crimson

Paint the water, starting with a wash and changing into broken, horizontal brushstrokes.

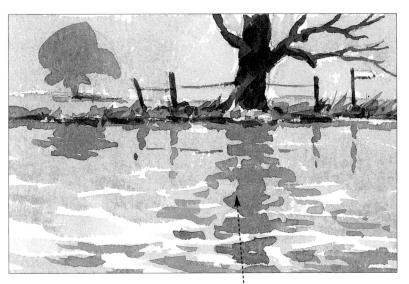

• Paint the reflections all the same color. Let them become more broken as you paint down the water to show the water movement.

Yellow Ocher + Alizarin Crimson + French Ultramarine

Snow

Creating the illusion of snow in a watercolor landscape is similar to painting water. Leave plenty of unpainted paper for the lightest snow, and use shadows to define the snow in the same way you use reflections to help create the effect of water. It is important to remember that a shadow falling on snow can be as dark as it would be on a normal landscape.

Late afternoon snow

Use warm colors in the distance to suggest the end of the day, and leave white paper to show the snow in the foreground. The shadows help to create the contours of the ground. Paint in the two people last to give scale to the painting. Paint the distant fields simply, with them becoming smaller as they approach the horizon. This creates the impression of distance.

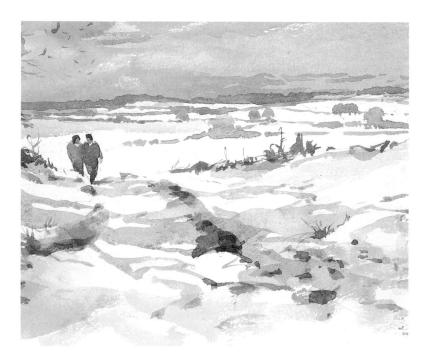

▲ First paint the sky down to the horizon with a large brush, then the distant hedges to suggest the fields using a small brush. Then paint the snow shadows with a large brush and foreground details with a small brush.

Thick snow

If you look at the first stage in this exercise, you can see how leaving just white paper for snow works well. However, notice also how it is flat with no form. You need to add shadows to define it.

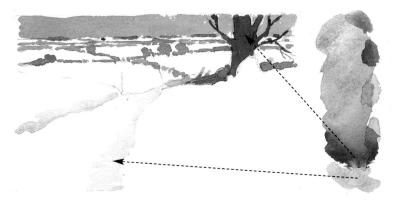

• Draw in with your 2B pencil. Paint the sky and distant trees, then the large tree and hedge, leaving white paper at the bottom of the trunk to represent snow. Paint in the two shadows to show the track.

Ceruleum + Alizarin Crimson + Yellow Ocher + Hooker's Green Dark

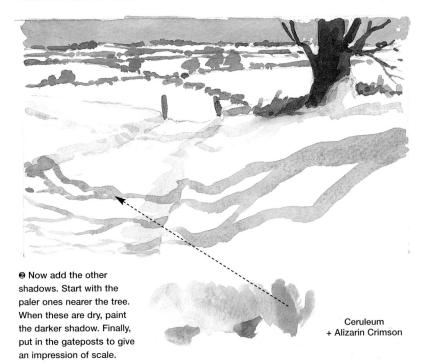

Mountains

Not all of us have the chance to paint mountains from life. If you do visit a mountainous area on vacation, take plenty of photographs when you are out sketching to use as reference once you are back at home. On certain days, you have to work quickly because a mountain can disappear behind mist or clouds within minutes, and it can remain hidden for hours.

Sunlit valley

By painting the mountains paler than the foreground, you can create the illusion of distance. The farthest mountain is painted smaller, adding to this effect (see page 48). The fir trees are only silhouettes, but, with the foreground boulders and fallen tree, they give the picture scale.

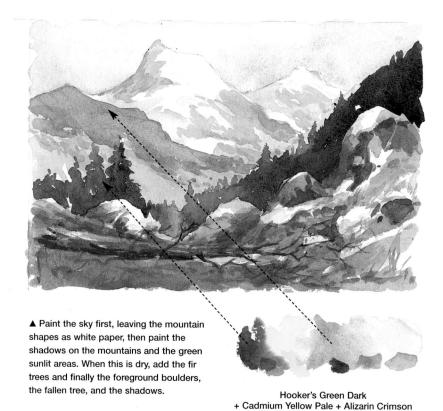

+ Ceruleum + Yellow Ocher

Mountains in summer

Mountains without snow sometimes look somber and uninteresting. However, if you catch them with the sun on them, they will change dramatically. When you are sketching outdoors, you often have to wait for the sun to hit your mountain, but it's worth the wait.

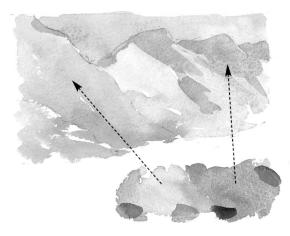

• Paint in the sky and go over the distant mountains. When dry, paint a darker shadow on the farthest mountain, then continue painting the others. Let your brushstrokes follow their downward slopes.

Hooker's Green Dark

- + Yellow Ocher
- + Alizarin Crimson
- + French Ultramarine

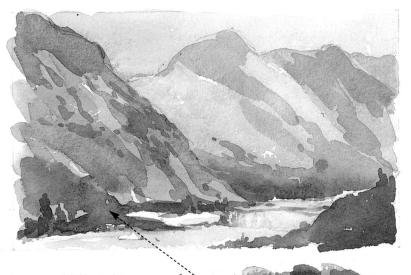

❷ Add more definition to the foreground mountain and valley. Suggest the fir trees on the left and paint the dark area between the first two mountains. Finally, paint the dark hill on the bottom right.

Misty mountains

This is possibly one of the most common mountain images—behind mist and cloud. It has drama and atmosphere and is exciting to paint. In this exercise, use the lifting-out technique to help create the misty look.

• Draw the mountain outlines with your 2B pencil. Paint a wash from top to bottom, changing the color as you work wet-in-wet.

French Ultramarine + Yellow Ocher

- + Alizarin Crimson
- + Hooker's Green Dark

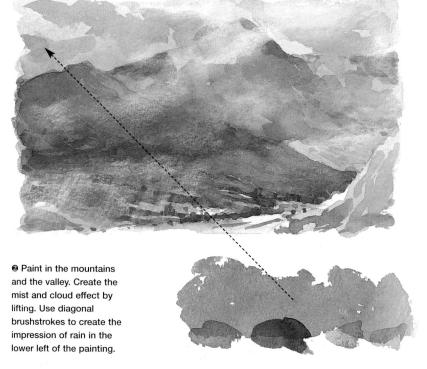

French Ultramarine + Alizarin Crimson + Yellow Ocher + Hooker's Green Dark Paint the sky a warm color in this painting to suggest an afternoon in late winter. Leave white unpainted paper to show the majority of snow on the mountain. Always make sure that you leave plenty of paper to show snow; you can always paint over it later if you have left too much.

Yellow Ocher + Ceruleum + Alizarin Crimson

• Paint the sky up to and onto some mountains. When this is dry, paint in the snow shadows, making sure your brushstrokes follow the slopes of the mountain downward.

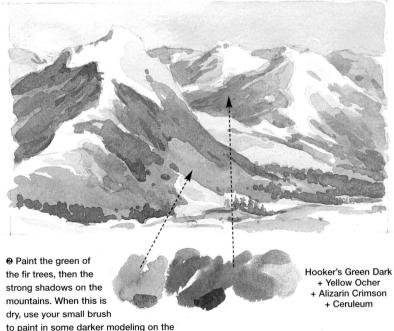

to paint in some darker modeling on the mountains and the fir trees in the valley.

People in landscape

People add interest and can help to animate even the most ordinary landscape. This section is not about learning how to draw people as you would in a life-drawing class, but how to simplify them to bring your watercolor landscapes to life.

People talking

People usually communicate with each other, even if they are just passing the time of day. Therefore, try to convey this in your paintings.

▶ Here are five bald heads. Below them hair has been added by painting just one brushstroke, making them look in definite directions. Features have not been added to the faces.

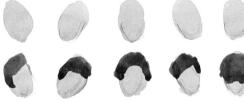

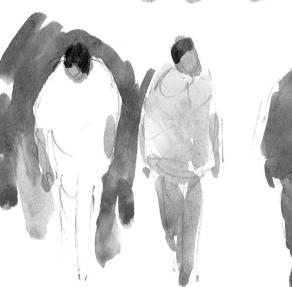

▲ The person on the left is looking down; the one in the center is looking at the person in silhouette on the right. You will find you paint many silhouette figures in landscapes. Keep your figures simple; don't be tempted to overwork them.

Sketching figures

Painting people, like other subjects, requires practice. On these two pages are sketches done from life and photographs. When you paint from life, you will have to learn to work fast as people move about. However, remember that you are not looking for detail. When you work from a photograph, you must still keep the figures simple. If you don't, they will be too carefully painted for you to add to your landscapes.

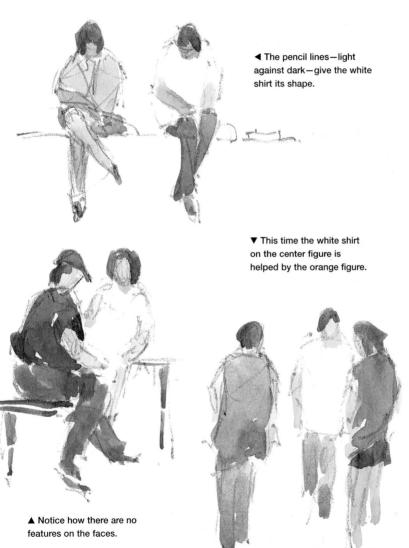

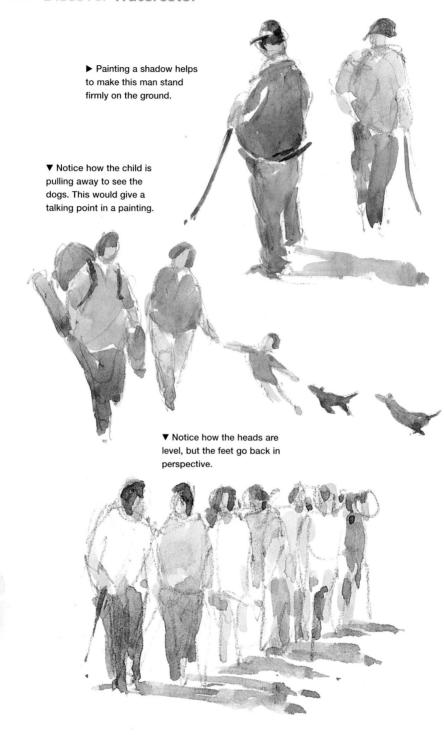

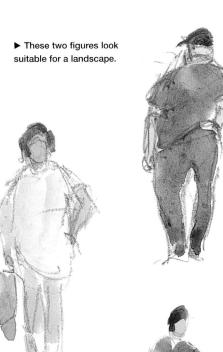

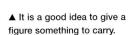

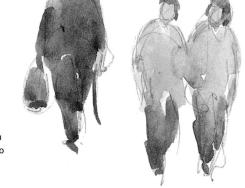

MUST KNOW

Copying photographs

A good way to start painting people is to copy photographs—they don't move! Make them simple like your sketches. Give yourself a time limit: start by allowing yourself two minutes, then reduce it to one minute, and, finally, just 30 seconds or less. You will be surprised at how fast you can sketch! Do not add detail and do not paint them any larger than the ones on these pages. When you are happy with the results, paint them from life but keep them simple.

Animals in landscape

Animals can add atmosphere to landscapes. However, they will not pose for you to paint, so you must sketch as much as you can from life and take photographs to work from later. Be careful to keep an eye on scale, especially when painting small animals, such as chickens or rabbits, because it is easy to paint them too large for the surrounding landscape.

Cows in a field

Draw two or three cows from a photograph, and put them in an imaginary landscape. Notice how the left cow stands out because its back is white against the dark trees. When cows are looking at you, you will see their typical expression of mournful curiosity!

▼ You should first paint the background, then the dark trees and cows. Add the grass in two washes, using single brushstrokes to represent movement.

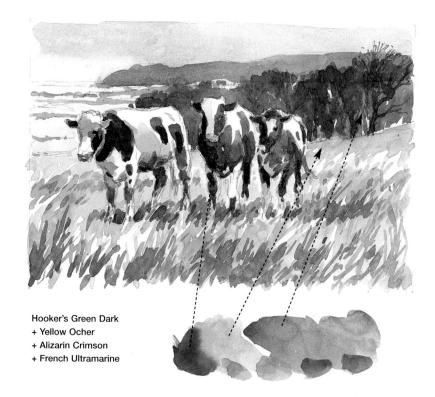

Sheep are easy to draw and paint. In the distance, you can suggest them by small areas of unpainted paper. Close up, simplify them by making oblong boxes with four thin poles for legs and an oval-shaped head.

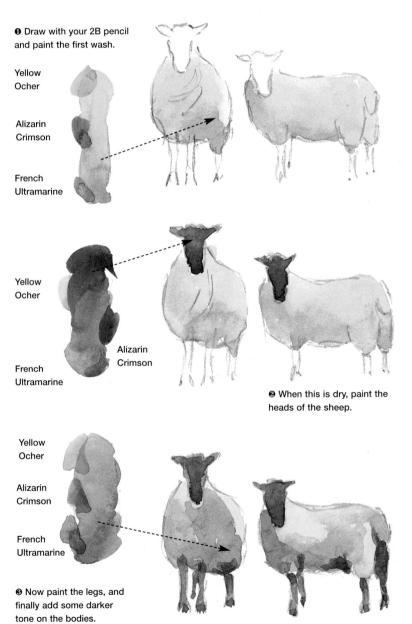

Cow

You may be lucky and find a cow that will stay in one position for three or four minutes, long enough for you to do a quick sketch. Try sketching from life, because it will teach you a tremendous amount. Cows give a landscape painting a sense of serenity and well-being.

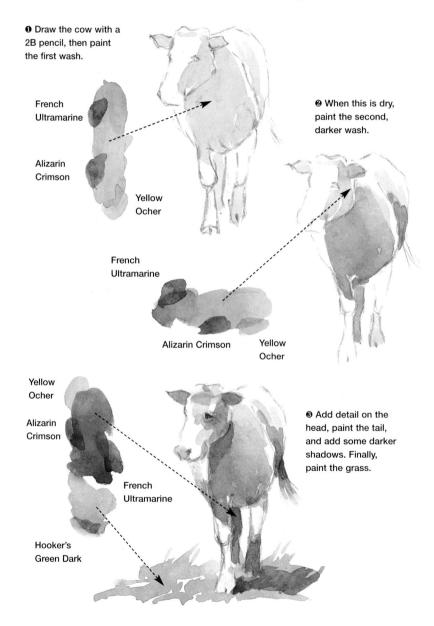

By sketching a pony that has been tethered, it will look as though it has been working hard and is now resting—or it is thinking of the work it still has to do! Including horses in your landscapes will suggest work is being done on the land.

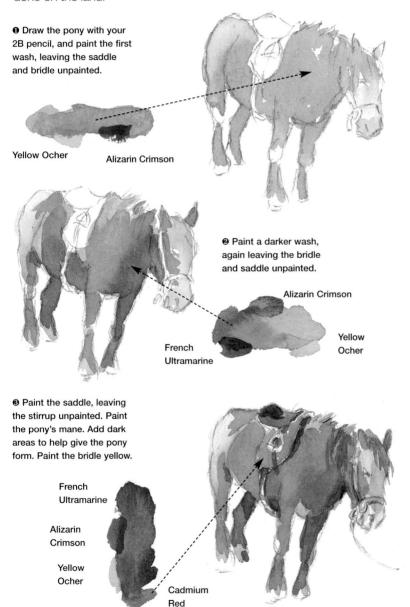

EXERCISE

Paint a rural landscape

In this exercise, the cows and the relaxed attitude of the man give the painting the feeling of a perfect summer's day. Remember that even small paintings like this one, which was painted the same size as it is reproduced here, can convey feelings to the onlooker.

The palette

French Ultramarine

Yellow Pale

Hooker's Green Dark

Alizarin Crimson

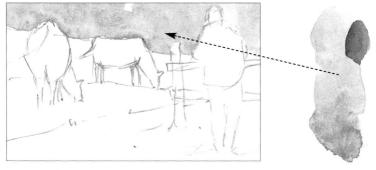

• Draw the scene with your 2B pencil, and, using your small brush, paint the sky. Notice how one or two small areas are left unpainted to show clouds.

French Ultramarine

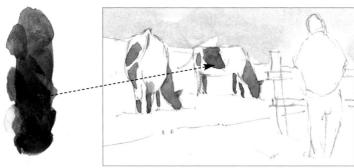

French Ultramarine + Alizarin Crimson + Cadmium Yellow Pale

② Using your small brush, paint the black markings on the cows, following the contours of the bodies.

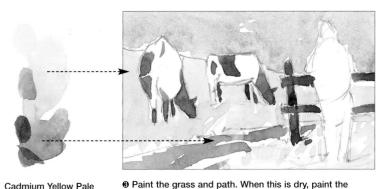

Cadmium Yellow Pale + Hooker's Green Dark + Alizarin Crimson + French Ultramarine

Hooker's Green Dark fence, leaving the man as white paper.

+ Alizarin Crimson

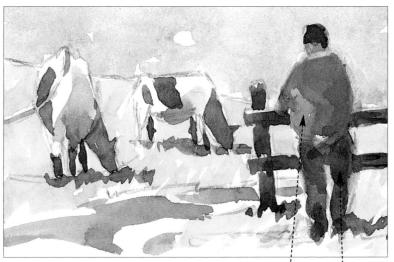

• Paint the man, then add some simple shadows on the cows and the cast shadows on the grass.

Cadmium Yellow Pale + Alizarin Crimson + French Ultramarine

Buildings

You can paint hundreds of perfect landscapes without putting in one building. However, buildings, like animals and people, can add interest to a landscape. In their simplest form, they are just like the box painted on page 24. To simplify them at first, try to imagine them as building blocks.

Farmhouse

that shadows create form

and show shape.

This farmhouse in its simplest form is a box with a roof. The porch is also a box. The three-dimensional look is created by adding shadows. The church is painted simply; it is just a silhouette with no detail. This is another way to make buildings simple to draw and paint.

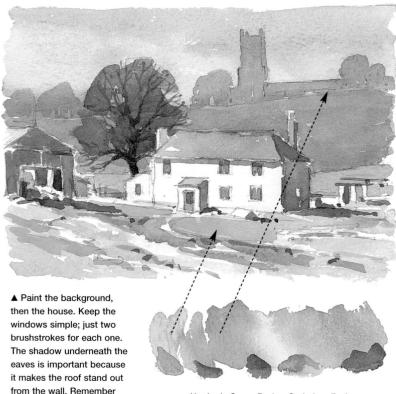

Hooker's Green Dark + Cadmium Red + Alizarin Crimson + Yellow Ocher + French Ultramarine

Simplified buildings

If you are working from a photograph, middle-distance buildings will usually look smaller than in real life. This is natural when you use a camera. Your eyes see the buildings larger as they unconsciously close in on them.

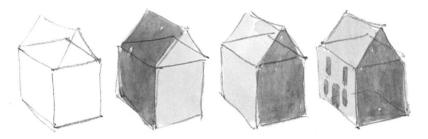

▲ Here you can see how light against dark defines the shape of the building.

- ► The yellow painted area is a meaningless shape. However, if you add some shadows, it becomes a group of houses.
- ▼ Painting buildings in silhouette makes them easier to portray. The only detail in this sketch is the three windows.

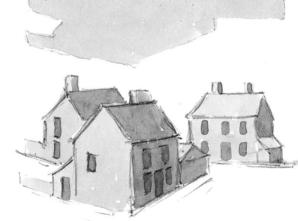

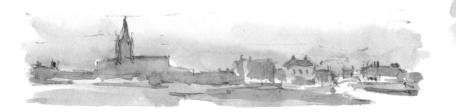

Discover Watercolor

Mediterranean farmhouse

This is an easy farmhouse to draw. It is made up of just four boxes. The cypress trees behind help to define the outline shape, light against dark. Notice how the windows on this building are simple dark brushstrokes.

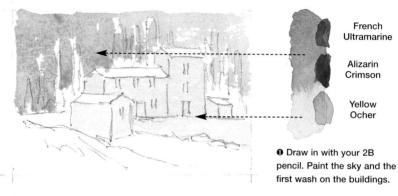

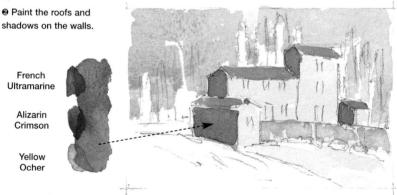

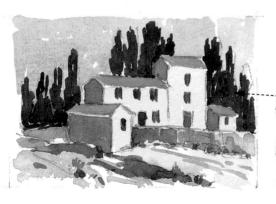

Paint the cypress trees, darken the wall, and put in the windows. Finally, add some foreground.

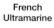

Alizarin Crimson

Hooker's Green Dark

Row of houses

This group of houses is more complicated to paint than the last exercise. However, study the painting carefully and you can see how it is still made up of light and dark areas. If you practice, you will be able to paint this well.

- Draw in with your 2B pencil. Paint in the sky and the first wash on the buildings. When the sky is dry, paint the tree.
- Paint the shadows and windows. Paint the ground wet-in-wet, and paint up onto the main house wall to give it character. Add grass detail. Paint in the telegraph pole and the smaller tree.

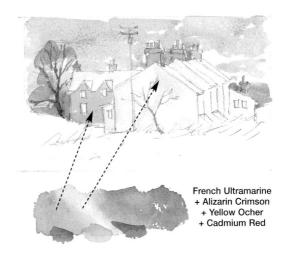

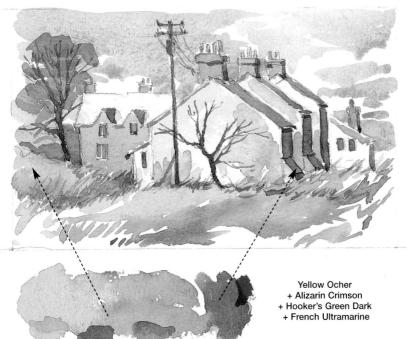

Sketching buildings and other features

Always carry a sketchbook with you to record objects you see outdoors. You can sketch a full scene or a small detail, such as a leaf, a branch, or a gate. If you have a camera with you, take a photo of the objects you sketch. This will teach you a great deal about working from photographs, especially about how the camera sees things and how you see them and sketch them. Photographs are a great source of information and inspiration when you are working indoors.

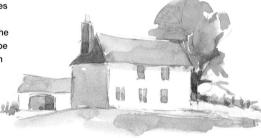

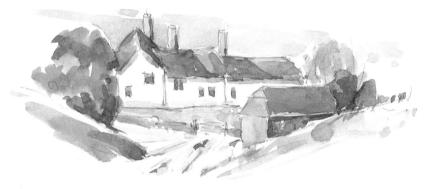

▼ This painting is a little more complicated. The water is simple yet effective.

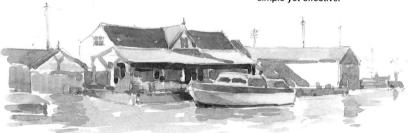

▼ This sketch of a stile is useful to practice.

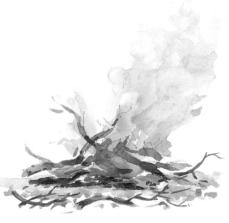

▲ The smoke and flames from this fire were painted wet-in-wet after the branches were painted.

▲ Seagulls on a plowed field can be seen near a coast. Although this sketch looks complicated, most of it is suggested, with unpainted white areas for the distant seagulls and details only added in the foreground.

want to know more?

Take it to the next level...

Go to...

- ➤ Seas: page 94
- ▶ People on the beach: page 116
- ► Composition: page 156

Other sources

- ► Sketchbooks essential for improving observational skills
- ► Local art club or society you may need to be a member
- ► Museums and art galleries good sources of inspiration
- ► Publications
 visit <u>www.harpercollins.com</u> for
 HarperCollins art books

painting the

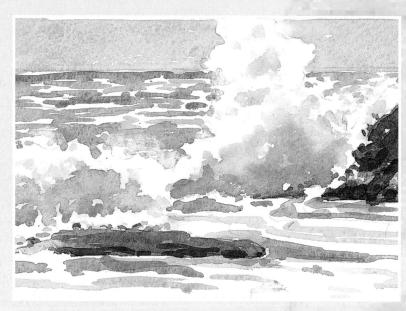

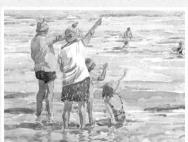

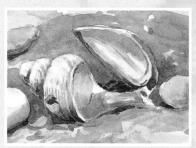

seashore

The seashore is a wonderful place to paint. It can be exciting in the summer when the beaches are crowded with vacationers, or in winter when the sea is rough and the sky is changing constantly. In any season, it is relaxing to pick up shells or look for a place to paint. Your paintings can be memorable keepsakes, and your sketches good reference.

Techniques

Here are some exciting techniques that will help you become a fully fledged seashore artist. You will get to know your brushes and paints, and the effects you can achieve with them.

Dry brush

How can you paint with a dry brush? Well, it isn't actually dry, just dryer than normal, so if you drag the brush along the paper, the paint hits and misses as it goes along, leaving some white paper showing. This gives a lovely sparkly effect, which is good for painting water or pebbles on the beach. This technique is more effective on rough-surfaced paper.

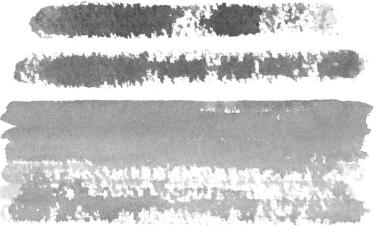

▲ Here, the dry-brush technique is used to show sunlight sparkling on the sea.

▲ A few darker marks over dry-brushed "sand" give the impression of pebbles on a beach.

Using a rigger brush

The hairs on a rigger brush are long and thin and all the same length. This enables a brush full of wet paint to continue producing the same thickness of line for a long time. The less pressure you use, the thinner the line will be. A rigger is mainly used for painting the rigging on boats, but it is useful wherever you need to paint fine lines.

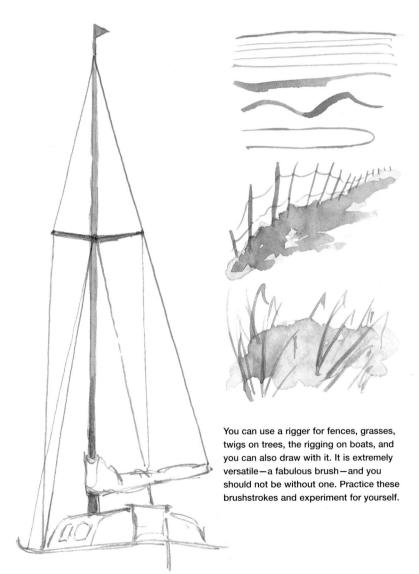

Blotting with a tissue

Another technique used to remove paint from your picture is blotting, but unlike lifting, where the original paint has to be dry, when you use the blotting technique the paint must be wet. A rolled-up tissue is used to remove areas of wet paint. Blotting is more spontaneous than lifting, which makes it a more suitable technique for soft subjects with irregular outlines, such as the clouds and waves shown below.

▶ Paint in the blue sky, leaving some paper white. Scrunch up a tissue and, while the sky is still wet, blot out some cloud shapes. When dry, paint in the cloud shadows.

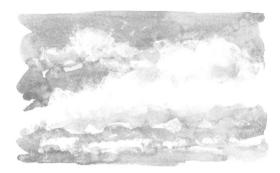

▲ Add a little green to blue and paint in the sea, leaving some white unpainted paper.

While this is still wet, blot out the spray on the waves with a tissue, then paint in the sand.

Shadows

Shadows are important in a painting because they add sunshine and life. To paint them successfully, all you have to know is how to mix the shadow color and where the light is coming from. Shadows vary in length at different times of day, and they are darker or lighter depending on the strength of the light. They also help to make objects look three-dimensional.

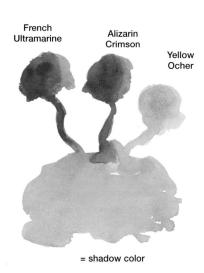

3

 $\ensuremath{\blacktriangle}$ Here, the sun is coming from behind the spade stuck into the sand.

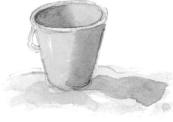

▲ The sun is shining from the left of this bucket in the sand.

▲ Because watercolor is transparent, when you paint the shadow color the underneath color will show through, but darker, giving the illusion of a shadow.

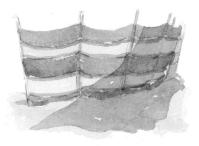

▲ This picture shows a shadow cast by another object, falling on a windbreak.

Shells and pebbles

You can find an amazing selection of shells and pebbles on the beach. They have interesting shapes and wonderful colors. You can paint or draw them where you find them, or take them home to work from. Either way, this is a simple but rewarding subject to practice with your watercolors.

Broken shells

This painting has been included to give you inspiration, and to show how just a few varied pebbles and shells can make an interesting painting. Next time you are at the beach, look out for these "ready-made" subjects.

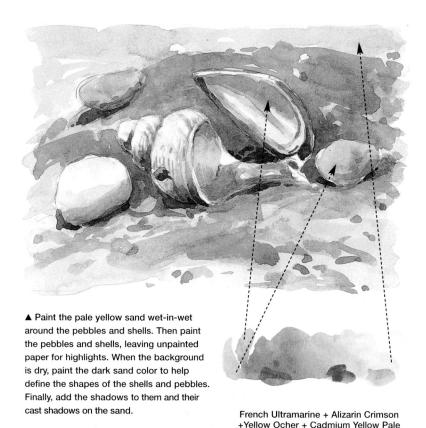

When someone says "paint a pebble" it sounds uninspiring. However, take a closer look at pebbles and you will find beautiful colors and patterns on them. It's always a delight to find pebbles on the beach. They are an easy subject for a beginner because they are such simple shapes.

• These two pebbles have elegant shapes. Draw them with your 2B pencil. Using your small brush, paint the large one soft gray, the other pale yellow with a little gray, wet-in-wet.

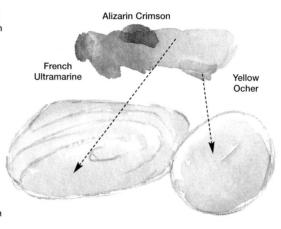

Paint the rings on the large pebble and let it dry. Then paint the shadows on both pebbles.

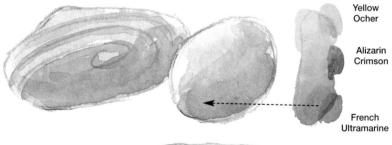

Paint the cast shadows on the ground, leaving a thin white highlight underneath both of the pebbles.

> French Ultramarine

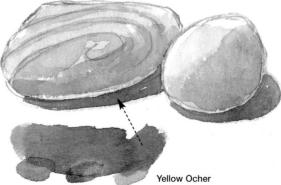

Alizarin Crimson

Scallop shell

The scallop shell is shaped like a fan. Don't worry if yours is a little different from the one shown below; concentrate on the ridges and the dark pink lines around the shell because they help to give it its familiar form.

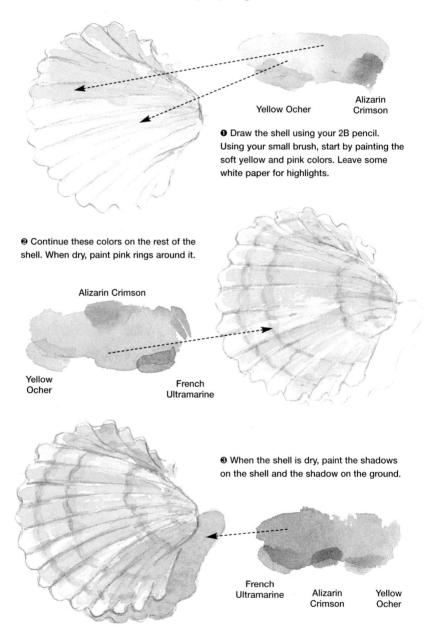

Sketching shells

Shells on the beach are almost as easy to sketch as painting indoors. They don't move, and, if you are lucky with the weather, you have plenty of time to sketch them. Try copying these sketches. Note how the darks and lights give the shells form and help them to look three-dimensional.

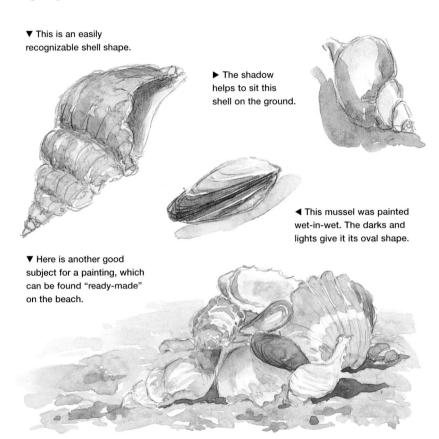

MUST KNOW

Making individual shells important

Paint them dark against a light-colored background or paint them light against a dark-colored background. Make some of the background shells less distinct and the nearest shells and foreground stronger. This will make them appear nearer and more important. Adding shadows will help to make shells appear three-dimensional.

EXERCISE

Paint shells and pebbles

By making sure the shells and pebbles are not too crowded together, you can see their distinct shapes, making them easier to paint. Background pebbles are kept less distinct to create the impression of distance.

The palette

French Ultramarine

Yellow Ocher

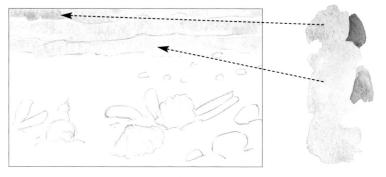

1 Draw the scene with your 2B pencil, then paint in the sea using your large brush, wet-in-wet.

French Ultramarine + Yellow Ocher

French Ultramarine + Alizarin Crimson

- + Yellow Ocher
- @ Carry on painting the sea wet-in-wet and continue into the sand around the pebbles and shells.

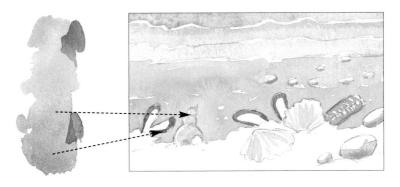

Alizarin Crimson + French Ultramarine

When dry, start painting the pebbles and shells with your small brush, leaving some unpainted paper for highlights.

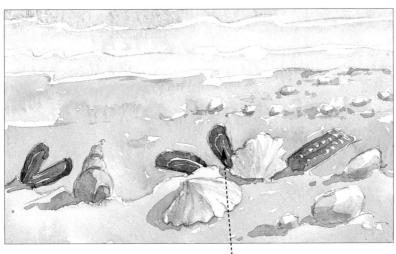

• Paint the foreground sand around the shells and pebbles. Add more color to these, let them dry, then add shadows.

Yellow Ocher + Alizarin Crimson + French Ultramarine

Marine life

Many living creatures are found at the seaside. This section illustrates a few of the fascinating crustaceans, seaweeds, and fish you may see. After practicing painting these, you will be able to paint many others of your own choice. You can also practice painting different types from photographs.

Crabs

Among the most commonly seen creatures on the seashore are crabs. You will find them in all types of environments: in tiny tide pools, under pebbles, and in the open sea. They vary greatly in shape, size, and color. Their subtle coloring makes them fascinating for an artist to paint.

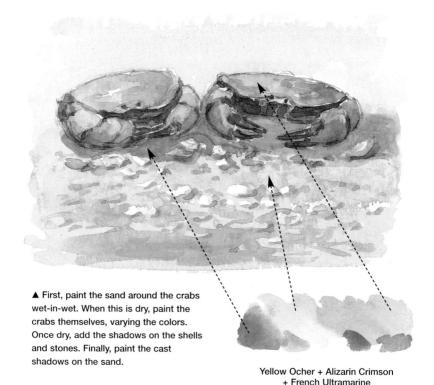

Shrimp

We are used to seeing pink shrimp, but they are this color only after they have been cooked. The shrimp that we see in tide pools are generally similar in color to the one painted here. You will find that your rigger brush comes in useful for painting the shrimp's long feelers.

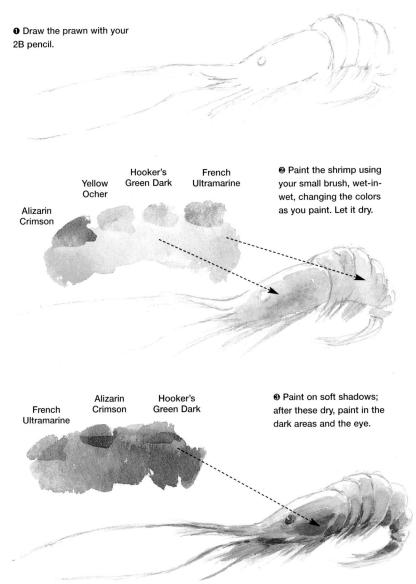

Discover Watercolor

Starfish

Walking on your local beach, you may be amazed at how many starfish you see. Photograph one in its natural setting, then use this to paint from at home. The shape and the colors will make an interesting painting.

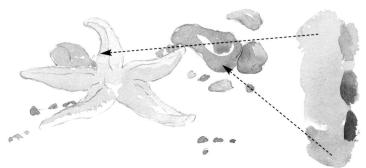

• Draw the starfish and stones with a 2B pencil. With a small brush, paint the starfish with a pale wash, leaving some white unpainted paper. Paint the gray stones, leaving highlights on the large one. Paint the orange stones and let it dry.

Yellow Ocher
+ Alizarin Crimson
+ French Ultramarine

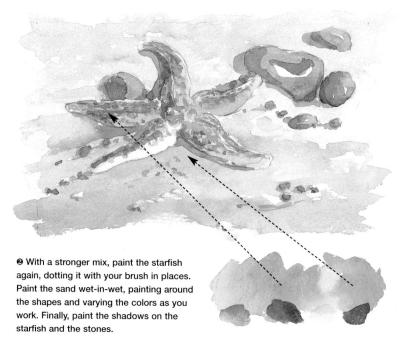

Yellow Ocher + Alizarin Crimson + Cadmium Yellow Pale + French Ultramarine

Seaweed

This is just one of the many varieties of seaweed found on the seashore. Seaweeds are many colors: browns, yellows, reds, and greens. They are usually different colors when wet and when dry. Sketch different seaweeds next time you are on the beach, or take them home to sketch.

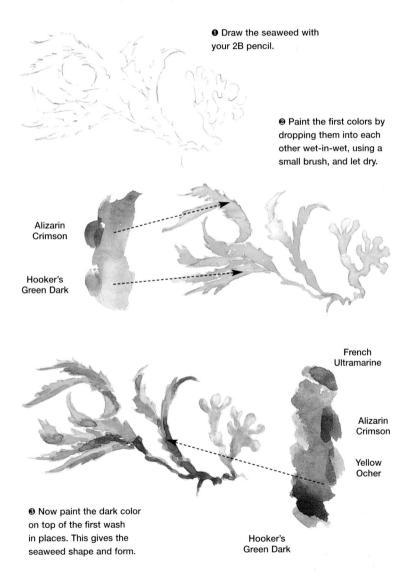

Seas

Water is wonderful to paint, especially the sea. Its moods and colors change constantly. From a large seascape to a close-up of a wave, it is an inspiring and challenging subject. Enjoy copying these exercises; they will give you a glimpse of the many opportunities the sea has to offer an artist.

Swelling sea

The painting below shows the many colors and patterns that you can find in the sea. The colors will change with the reflections on the sea when the sunlight is shining through it. They will also vary depending on what is hidden underneath the surface.

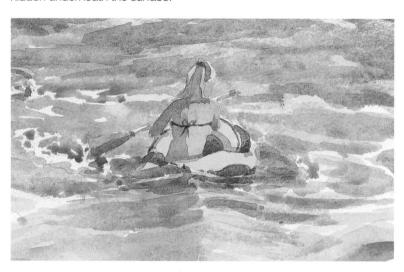

▲ Paint the sea first, leaving the girl, the boat, and the movement lines in the water as unpainted paper. When dry, paint the girl and the boat, then the reflections on the water. When these are dry, paint in all the shadows. Notice the simplicity of the shadow on the girl and of the water itself; don't be tempted to overwork it.

MUST KNOW

Painting waves

Leave the foam of the waves as white paper, and make the shadows under the waves dark. You can always "lift" the paint (see page 19) if these areas are too dark.

Waves breaking on a beach

Waves can change color and shape according to the weather, the type of sea bed lying underneath, and when they are crashing onto rocks. Always leave plenty of white paper for the foam—you can paint over it if you have left too much. In this painting, the waves are breaking onto a beach.

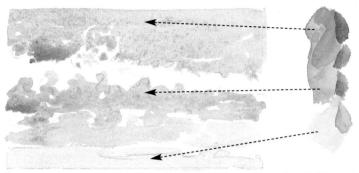

• Draw in the basic shapes with a 2B pencil. Then, using your large brush, paint the sea as a graded wash, leaving some white paper for the foam.

French Ultramarine + Alizarin Crimson + Hooker's Green Dark + Yellow Ocher

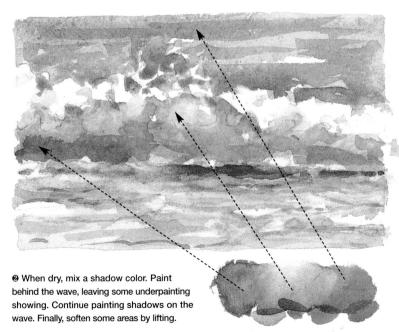

Yellow Ocher + Hooker's Green Dark + Alizarin Crimson + French Ultramarine

Discover Watercolor

Calm sea

In the painting below, this is a completely different sea to the one depicted on the previous page. It is more the color found around a tropical island, and the overall atmosphere is extremely tranquil. This is a perfect example of water painted simply, without overworking.

• Paint the sky using your large brush. When it is dry, paint the headland with your small brush. Let that dry, then start painting a wash for the sea.

French Ultramarine
+ Alizarin Crimson
+ Ceruleum
+ Yellow Ocher

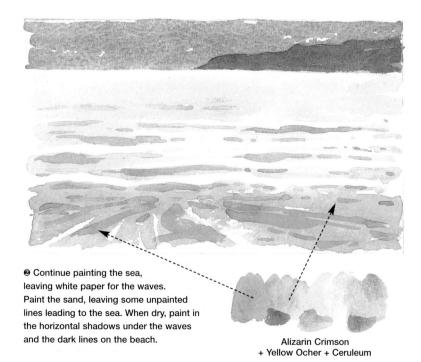

Waves crashing on rocks

This is a lively scene with waves crashing onto rocks, creating a lot of spray. The color of the sea, the sparkling white of the waves, and the dark rocks make the painting vibrant, and the contrast of the dark areas with the white paper adds dimension and drama.

• Draw in with your 2B pencil. Paint the sky with your large brush, leaving the wave unpainted. Then paint the sea, leaving small white horizontal areas for the background waves. Add soft shadows to the spray.

French Ultramarine + Alizarin Crimson + Hooker's Green Dark

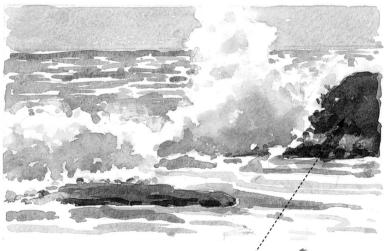

Paint the dark rocks, leaving little specks of white paper to suggest spray. Paint darker areas on the spray, wet-inwet. Then paint the sea around the rocks with horizontal brushstrokes.

Hooker's Green Dark + Alizarin Crimson + French Ultramarine

EXERCISE

Paint a seascape

When you paint this scene, the first two stages are painted while the paint is still wet, so don't stop in the middle, just keep going. Your colors may vary from here, because they will merge differently when they are wet.

The palette

Ceruleum

French Ultramarine

Yellow Ocher

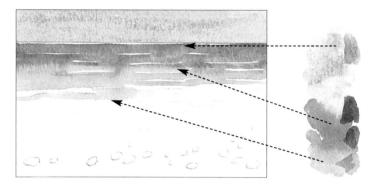

• Using your large brush, paint the sky and sea, leaving a thin unpainted line on the horizon. This prevents the sea merging into the sky.

Ceruleum
+ Alizarin Crimson
+ French Ultramarine
+ Yellow Ocher

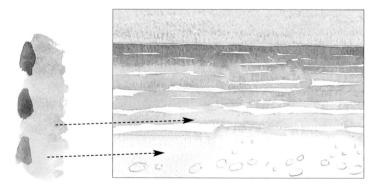

French Ultramarine + Alizarin Crimson + Yellow Ocher Paint the sea and the sand, using the graded wash technique. Leave horizontal white paper lines for the waves.

9

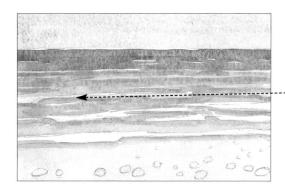

 $\ensuremath{\mathfrak{G}}$ Finish painting the sand. When it is dry, paint the shadows under the waves. Leave it to dry.

French Ultramarine
+ Alizarin Crimson
+ Yellow Ocher

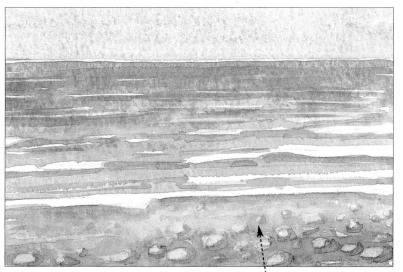

• Use your small brush to paint in the darker sand, leaving the stones pale yellow. When dry, paint in the shadows on the stones.

French Ultramarine + Alizarin Crimson + Yellow Ocher

Cliffs and rocks

Cliffs and rocks play an important role when you are painting the seashore. They give scale and stability to a seascape painting. They can also help you to paint a recognizable place, especially if they have distinctive shapes. Cliffs also vary in color depending on the underlying rock.

Cliffs in silhouette

this is dry, add the shadows.

One of the many ways of painting cliffs is to paint them when looking toward the sun. The cliffs become silhouettes and the sea is so bright, it is almost white. You can hardly see the green of the trees and fields on the cliff, and the cliff itself is too dark in shadow to see its colors.

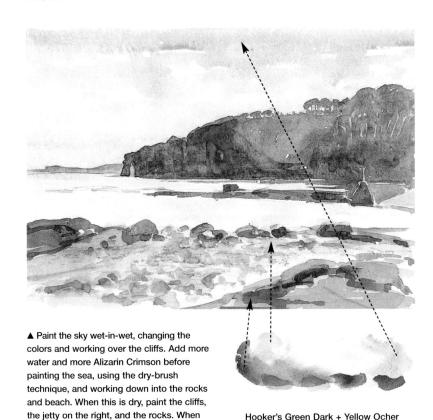

+ Alizarin Crimson + French Ultramarine

Distant cliffs

Look carefully at the shapes and colors of cliffs before you start to draw and paint them. Just a few minutes spent looking and observing all the details will help your painting to be believable and give you confidence.

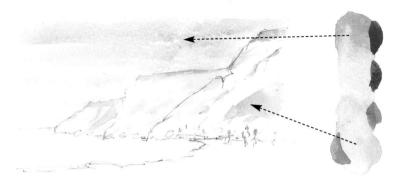

• Draw the scene with your 2B pencil. Paint the sky with your large brush, going over the far cliff and the sea using the dry-brush technique. Paint the greens on the cliffs, using warmer colors on the nearest cliff.

French Ultramarine + Alizarin Crimson + Hooker's Green Dark + Yellow Ocher

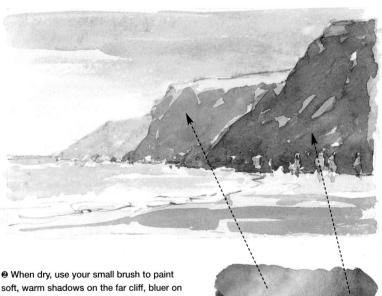

When dry, use your small brush to paint soft, warm shadows on the far cliff, bluer on the middle cliff, and add more red and green paint on the nearest cliff, leaving white shapes for the figures. Add more color to the sea and sand. Finally, paint the figures.

French Ultramarine + Alizarin Crimson + Yellow Ocher + Hooker's Green Dark

Discover Watercolor

Rocks

Rocks are in some ways just small versions of cliffs, or big versions of stones. The rocks in this painting are brightly colored. In some places, you will find they are gray, black, or even green where seaweed has stuck to them.

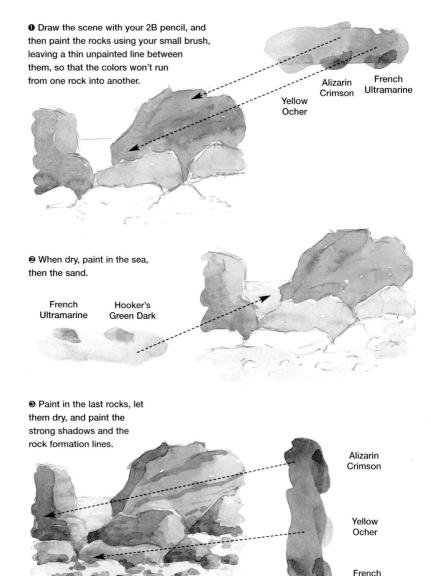

Ultramarine

Magical, miniature water worlds full of life, tide pools are loved by children and adults alike. They can be large or small. The colors vary according to the type of pool, what is in it, and the reflections on it.

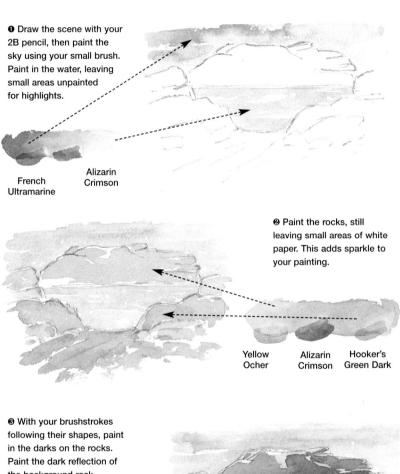

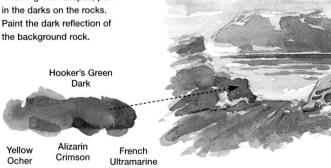

Sea birds

The most easily recognized sea birds are the seagulls. There are many different types and you will often see flocks of them soaring in the sky or groups scavenging on the beach. They will give life and movement to your seascapes.

Flying seagulls

The painting below is typical of a flock of seagulls "playing" over the sea. A dark sky has been painted to emphasize the white shapes of the gulls. Don't attempt to add details to them because your eye will be drawn to individual birds rather than seeing the flight of the whole flock.

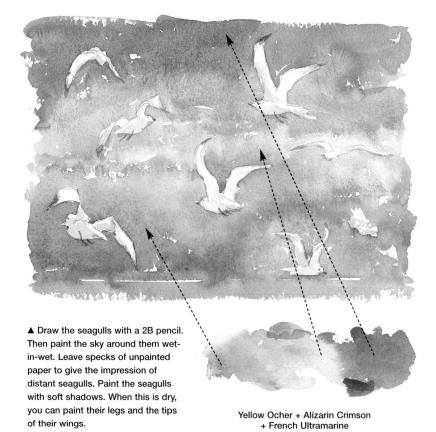

Black-headed gull

When they are flying, birds are usually graceful. Sometimes, however, especially if they are walking, they can look extremely comical, like the one painted here. It has a rather quizzical expression, as if it is asking for food.

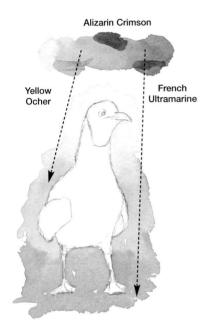

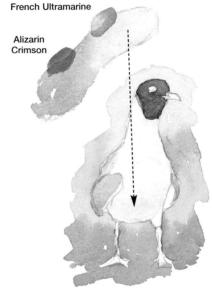

• Draw the gull carefully with a 2B pencil to get the correct shape. Then paint around it with your small brush, wet-inwet. Leave it to dry. Next paint the head, leaving the eye white. Paint the wings, then paint in the soft shadow down the front of the bird.

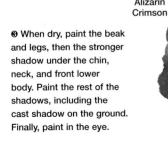

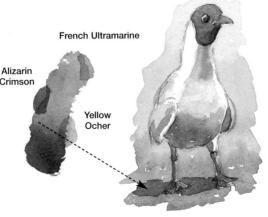

Discover Watercolor

Curlew

Curlews are distinctive with their long curved beaks and slender legs. This is a lovely shape to draw with long, flowing lines from the beak down under the chest and over the top of the beak to the tail.

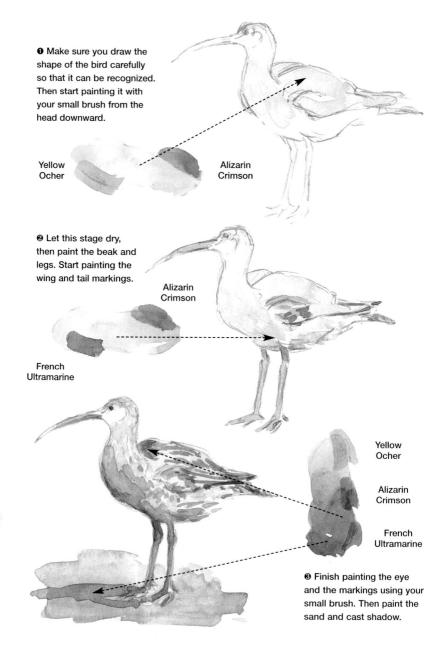

Sketching sea birds

Sketching birds outdoors is difficult. They are constantly on the move and do not pose for long. However, it is good practice and fun to try to sketch them. Don't worry if you only get parts of them, and don't forget that you can also take photographs and paint from these.

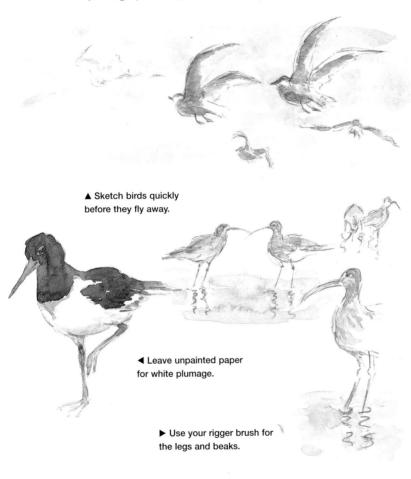

MUST KNOW

Sketching birds

If you are sketching a bird and it flies away, start another one—don't worry, it happens to all of us! Birds flying in the distance need only be simple shapes. When sketching a group, you need only two or three carefully drawn birds in front; illusion will do the rest. Keep reflections simple.

On the beach

In the summer, the beach is full of exciting subjects to paint, from simple sand castles to a more complex breakwater. Approach each new subject as a challenge and enjoy trying to paint many different things when you visit the beach.

Sand dunes

This is part of a larger painting and shows some high sand dunes, which are topped with coarse grasses, and long stretches of sandy beach. In the summer, many families come to the dunes to picnic and vacation.

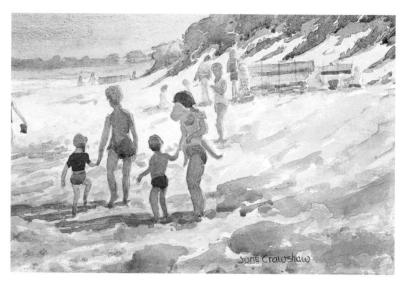

▲ You should paint the distant land and people soft and bluish to keep them in the background. Paint the windbreaks and middle figures in stronger colors, then paint the foreground people in the

strongest colors, giving depth and distance to the painting. Finally, add some strong shadows to the foreground people and the beach to give the impression of sunlight.

MUST KNOW

Creating distance

Distant people are small but get larger as they get closer. Distant hills and cliffs are bluer or paler, getting stronger and brighter nearer the foreground. Shadows are stronger in bright sunlight.

Most beaches have some pebbles. Look carefully at the scene below, and see how simply they are painted. Most of them are merely suggested, with the use of magical shadows to make them appear three-dimensional.

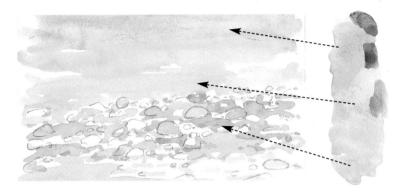

• Draw in a few pebbles with your 2B pencil, then paint the sand using your large brush and leave most of the pebble area as unpainted paper. When this is dry, paint in the gray and pink areas of the pebbles.

French Ultramarine + Alizarin Crimson + Yellow Ocher

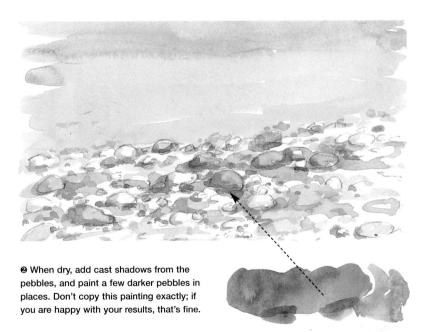

French Ultramarine + Alizarin Crimson + Yellow Ocher

Discover Watercolor

Breakwater

Breakwaters can make interesting little paintings close up, like the one below, or they can be used as important elements in a larger seascape. They can look new or may be worn away by the sea to almost nothing. They add interest and scale to a beach painting.

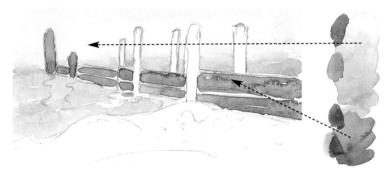

• Using your 2B pencil, draw in the scene. Then use your large brush to paint a blue-gray wash for the sky and the sea. Start painting in the breakwater.

French Ultramarine

- + Hooker's Green Dark
- + Alizarin Crimson
 - + Yellow Ocher

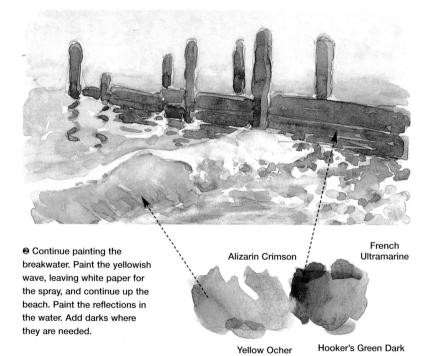

Beach huts

Beach huts are like brightly colored little houses, and they add color and life to a beach scene. Sometimes they are bleached by the sun and the sea and look wonderfully weathered. This exercise, of a row of three beach huts, shows you how simply they can be painted.

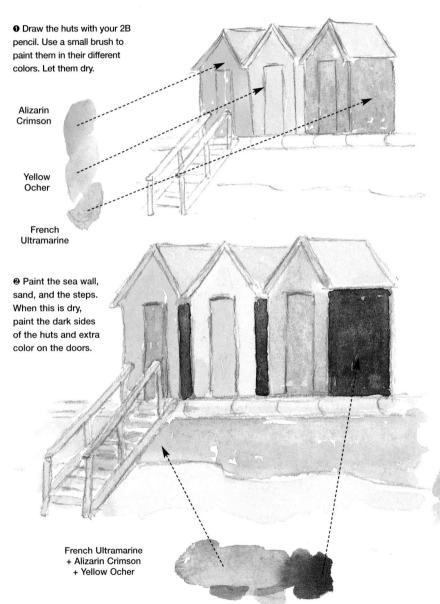

Discover Watercolor

Sketching at the beach

Don't forget to take your sketchbook when you go to the beach. There is always something for you to sketch. Practice by copying these pictures. Notice how the beach huts below and the breakwater opposite are painted more freely than those on the previous pages. This is because the sketches are painted as part of a scene and not as objects in their own right.

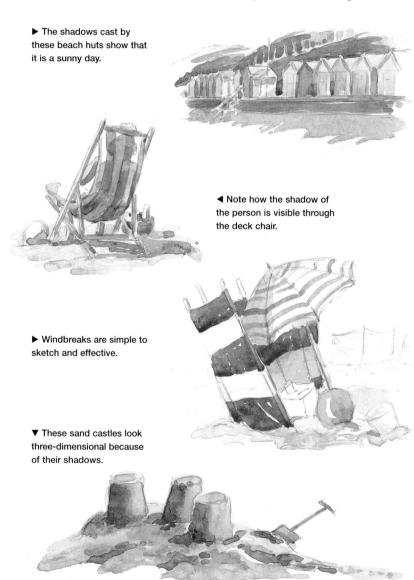

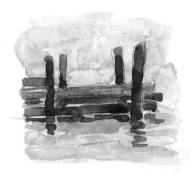

▲ Just one of the many ways to paint a breakwater.

▲ Drawn and shaded with a 2B pencil, then a few simple brushstrokes, and here are two donkey riders.

◀ The sky and sea were painted simply.

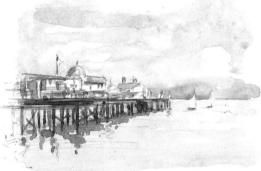

▼ Don't overlook subjects like this. They make interesting paintings.

MUST KNOW

Have a sketch

When sitting on the beach, always have your 2B pencil and sketchbook ready and look around you for a suitable subject to draw. Anything from a pebble to a group of bathers may be interesting subjects. Just go ahead and try to sketch them. Do not forget that bathers or sea birds will move, but there will be plenty more for you to draw. You can always try sketching some people who are asleep in deckchairs—at least they will not move!

EXERCISE

Paint a beach scene

This scene is painted from a rather unusual viewpoint, looking down on it from the top of the cliff. The breakwaters are a long way down and look small. The broken gate is close up, which helps give the impression of distance. The shadows help to hold the whole painting together.

The palette

Alizar

French Ultramarine

Alizarin Crimson

Hooker's Green Dark

Yellow Ocher

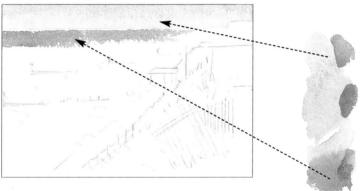

• Draw the scene with your 2B pencil. Paint the sky using your large brush, leaving a white horizontal line below it. Start painting in the sea using the dry-brush technique.

French Ultramarine + Alizarin Crimson + Hooker's Green Dark

Yellow Ocher + Alizarin Crimson

Ontinue painting the sea, adding more water as you work down. Next, paint the sand, leaving white paper for the hut.

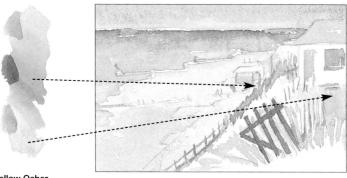

Yellow Ocher + Alizarin Crimson + Hooker's Green Dark

Using your small brush, paint the pink roof, hut, and grasses, then paint in the green grass. When dry, paint the windows on the building and the gate in the foreground.

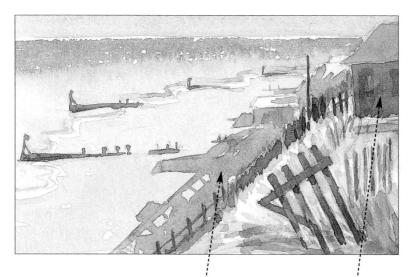

• Paint in the fences and breakwaters. When these are dry, paint the shadows from the cliff falling across the beach.

People on the beach

Seeing people enjoying the beach—children making sand castles, people swimming in the sea, grandparents watching—will make you want to capture these wonderful scenes. With the help of these exercises, you will soon be able to include people in your watercolor sketches.

Family vacation

This was painted from some pencil sketches made at the beach. The grandparents and the children are waving to the parents in the sea. The sea and the figures in the sea have been kept simple. The most important element in the painting is the group in the foreground.

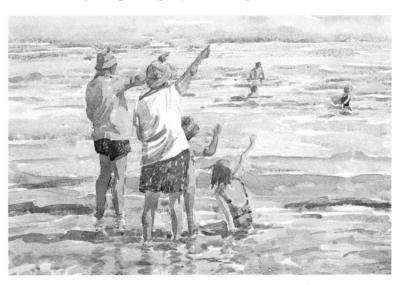

▲ Paint the sea simply, with the colors changing as you work down and around the figures with horizontal brushstrokes,

wet-in-wet. When dry, paint the figures, and, finally, paint in the shadows on the people and the sea.

MUST KNOW

Painting the sea

Always mix the colors you need before you start painting. Use a large brush filled with paint and plenty of water. Remember to leave white paper for any white-capped waves.

Placing people on the beach

When painting people on a beach, look for the horizon (this is your eye level). If the beach is level, the horizon will cross the people in the same place on their bodies (see below). Naturally, people are different sizes, and the beach isn't always level, but this gives you something to work with.

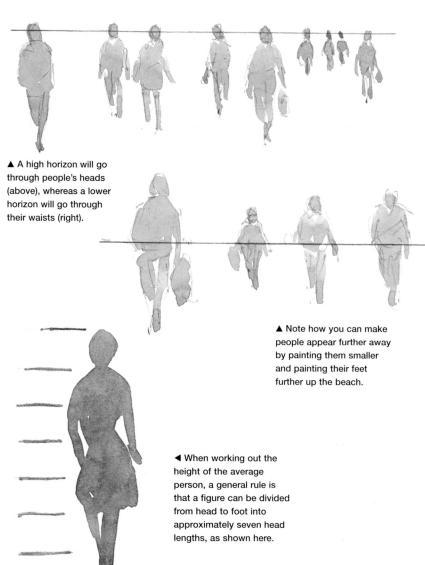

Discover Watercolor

Girl playing

Children come in all shapes and sizes and don't stay still for a minute, making them difficult to paint, so practice painting them from photographs. This girl is nearly all in shadow, and you can almost feel the sun on her.

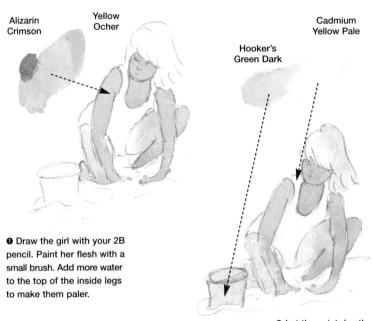

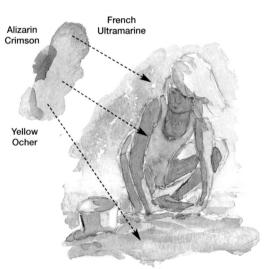

Let the paint dry, then paint the hair, swimsuit, and bucket, and let it dry again.

On the background, paint a wash using directional brushstrokes. When dry, paint over the girl's body with a wash of shadow color, leaving sunlit areas.

Group on the beach

You will see groups and couples on the beach. You don't want to put a lot of detail in them, because they are usually part of the scene and not the main subject. Too much detail would make them "jump out" of the picture.

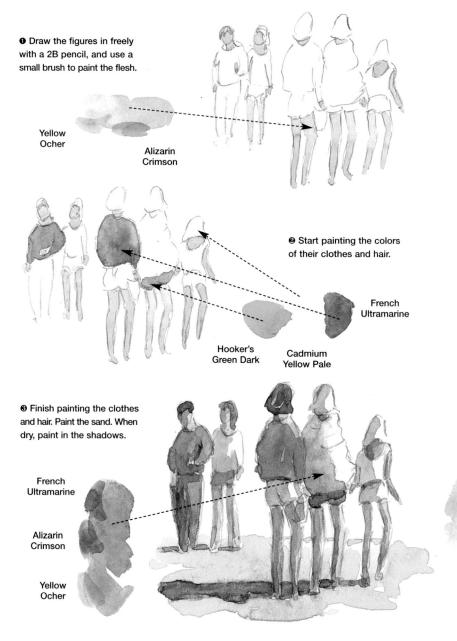

Sketching people on the beach

Like animals and birds, people never stay still. As you can see from these sketches, you will have to sketch quickly, and, even then, some subjects will be gone before you get any further than a few pencil lines. Don't panic! Be patient, keep drawing, and you will succeed. Start by copying the sketches here and also use photographs; this is an acceptable way to practice and will give you confidence when you go out to sketch.

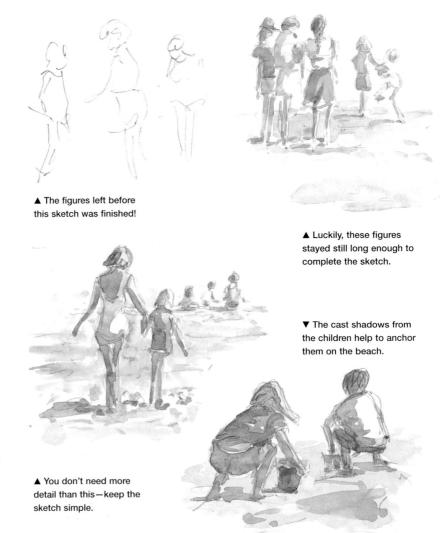

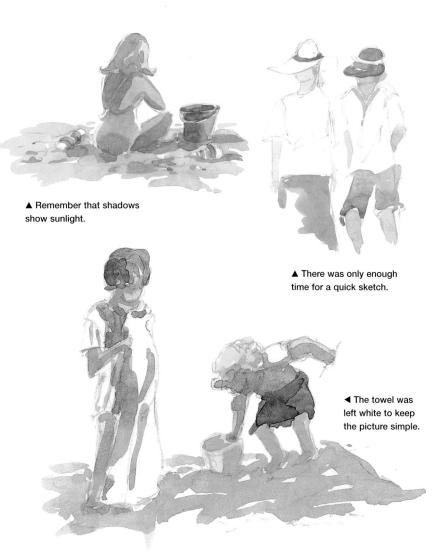

MUST KNOW

Working from photographs or television

As you have learned, people on the beach move, so why not take your camera with you to the beach, then you can practice painting at home, working from photographs. You can also sketch from the television by playing "slow motion" or still frames. As you gain confidence, sketch them at normal speed on the television, then from real life on the beach. Drawing anything that moves takes plenty of practice, so keep at it and enjoy it.

Boats

Some artists worry that painting boats will be difficult, believing them to be too technical, but, if you observe them carefully and sketch what you see, they are easy. Study a boat, how it sits in the water, and where to place the details. Don't worry, your boat doesn't need to be seaworthy!

Yacht race

This was painted quickly and freely. The dark cloudy sky and dark water contrast with the white sails of the yachts and their reflections. The sails and some of the boats were left white to create a more dramatic effect.

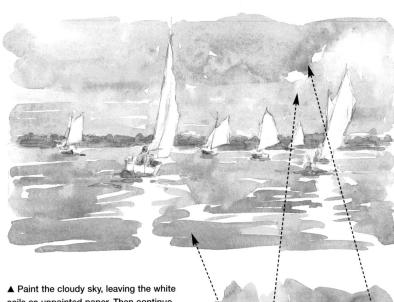

▲ Paint the cloudy sky, leaving the white sails as unpainted paper. Then continue into the water, changing colors on the way down, leaving unpainted paper for the reflections. When dry, paint the headland and boats. Notice how the sails are all blowing in the same direction.

Yellow Ocher + Alizarin Crimson + French Ultramarine

Rowing boat

This rowing boat looks relatively simple, but you will still need to study its shape to make it sit realistically, either in the water or on the sand. If you copy this one carefully, it will help you when you paint one on the beach.

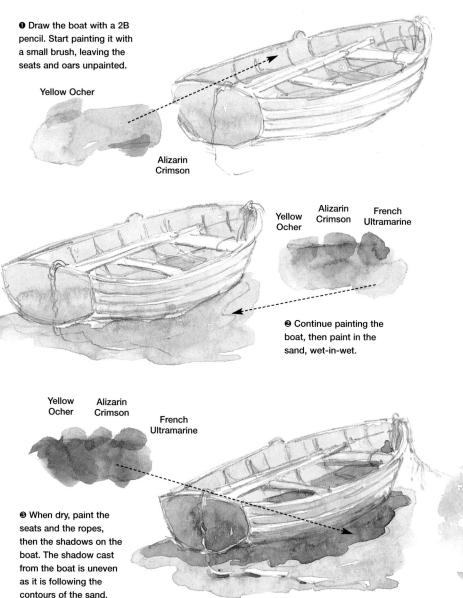

Discover Watercolor

Sketching boats

Sketching helps to gather information for paintings, gives you memories to keep, or can be done just for the pleasure of it. Sketches can be paintings in their own right but are not usually detailed. If you are doing a large sketch of boats, then use your rigger brush for the rigging, but if you are sketching on a small scale, you may prefer to use your 2B pencil.

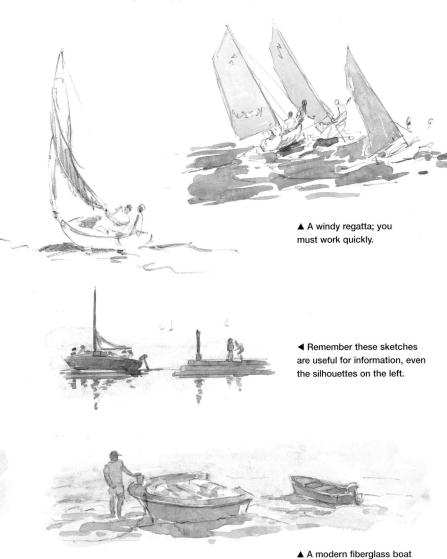

won't spoil your painting.

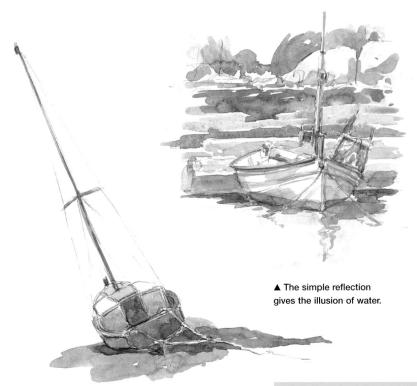

▲ Notice how the rigging lines were left as pencil.

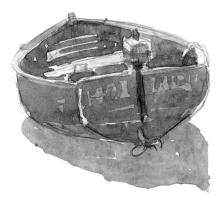

▲ The shadow from this rowing boat helps to sit it on the beach.

want to know more?

Take it to the next level...

Go to ...

- ► Creating distance: page 44
- ► Water: page 50
- ► People in landscape: page 62

Other sources

- ► Photographs
 useful sources of reference
- ► Art shows
 look out for local or national events
- ► Internet interactive CD-ROMs
- ► Painting vacations expand your horizons with other artists
- ► Publications
 visit <u>www.harpercollins.com</u> for
 HarperCollins art books

painting

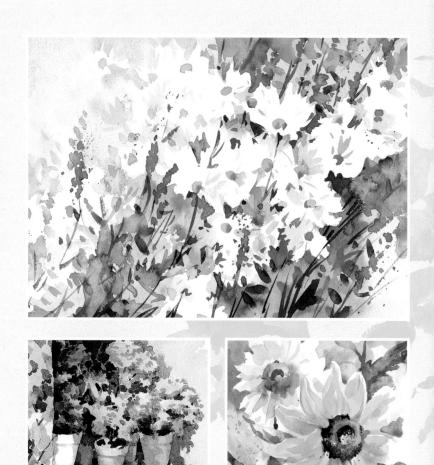

flovvers

Flowers are a joy to paint; their infinite variety in shape and color is an endless source of inspiration and challenge. Observation really is the key to revealing nature's secrets. The time that you spend looking at flowers will pay dividends in your painting, as you develop an understanding of how the shapes and colors relate to one another.

finishing back at the tip.

Using your brush

Painting in watercolor is all about learning to control your brush. When painting flowers, a variety of marks can be made with a round brush that comes to a tip.

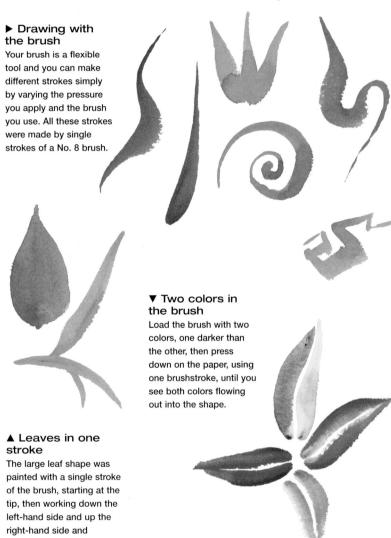

▼ Dry brush

Minimize the amount of liquid on your brush and drag it across the paper so that the pigment hits and misses the paper. This produces a sparkling effect and is useful for creating texture.

These can be created in two ways: You can either use water to form a shape and then add the paint, or you can paint the color in and then add water to soften the edge. This technique is most helpful in producing three-dimensional form.

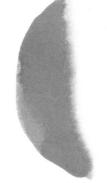

Splashing and spattering

Load your brush with paint and while holding it over your dry or wet painting, tap with your index finger on the handle of the brush. This is useful for adding random markings and texture.

MUST KNOW

Watercolor brushes

The best, and most expensive, brushes are made from sable; they have a long life, are ideal for holding a lot of liquid, and encourage a delicacy of approach. Synthetic brushes have a lot of spring and tend to be easier to control, but they do not hold much liquid and their ability to come to a point is not long lasting. A good compromise is to use brushes that are made from a synthetic–sable mix.

Flower shapes

The underlying shapes of flowers can help you to understand their structure. Recognizing and reproducing these shapes is all important to the confidence and simplicity of your finished work. This section shows you how to interpret the basic underlying shapes. All these exercises are worked using a No. 8 round brush. Have fun and invent some of your own.

Cup

This poppy is shaped like a cup. Thinking of it in this way will help you to simplify it when you are painting. You can try several times until you get the shape that you want.

• Starting with a pencil-drawn ellipse, draw in a triangular shape at the bottom to represent the underneath of the poppy, creating a cup shape. Clip out another triangle to represent the petals, add in the stem, and finish with another ellipse for the center.

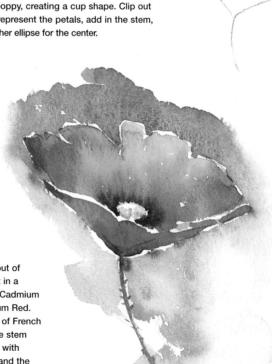

Cadmium Orange

Cadmium Red

French Ultramarine

Take more clips out of the petals and paint in a variegated wash of Cadmium Orange and Cadmium Red. Paint a background of French Ultramarine. Add the stem (French Ultramarine with Cadmium Orange), and the dark center (French Ultramarine with Cadmium Red).

Wheel

A clump of daisies always attracts the eye. Think of them as wheels with a hub and spokes, but without an outer rim. You can create the impression of the daisy with just a few brushstrokes.

• Paint the center of the daisy using Indian Yellow and a touch of Cadmium Orange to add definition and depth.

Indian Yellow

Cadmium Orange

Burnt Sienna

French Ultramarine

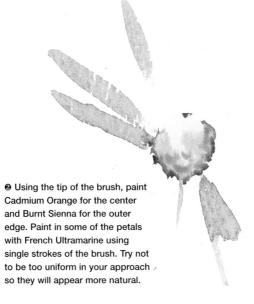

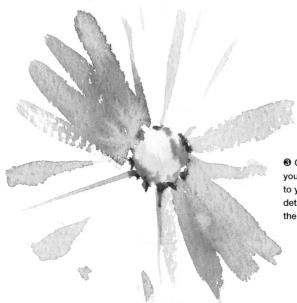

❸ Continue in this way until your painting says "daisy" to you. Don't add too much detail; leave some parts for the viewer's imagination.

Star

The star shape is seen in many forms in flowers. The star in the flower I've chosen doesn't need equal points; this gives it a more natural look.

Permanent

Mauve

Red

Yellow Ocher

O Start to map out the shape of the flower using use the brush to create a

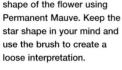

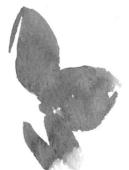

Ceruleum

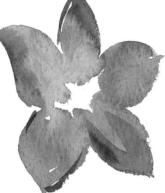

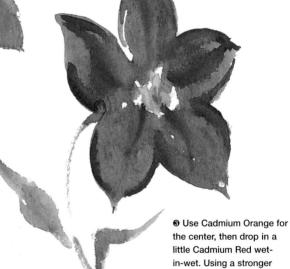

the center, then drop in a little Cadmium Red wetin-wet. Using a stronger concentration of Permanent Mauve, paint the striations and divisions on the petals. With single brushstrokes, add the stem and leaves, using some Yellow Ocher and Ceruleum.

Spiral

If you observe a rose developing from a bud to a full-blown flower, you will see that it evolves in a spiral formation from the center to the outside edge.

• Using Cadmium Red and Cadmium Orange, brush in the overall shape, allowing the colors to mix.

admium Cadmium Red Orange

French Ultramarine

O. Later St.

Indian Yellow

Alizarin Crimson

Using a mix of French Ultramarine and Indian Yellow, paint a simple leaf shape with two strokes of the brush, leaving a white space along the center to indicate its spine. With a mix of Alizarin Crimson and Cadmium Red, gently brush a few petal edges in, working from the center outward.

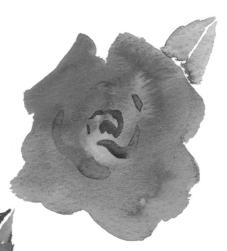

Discover Watercolor

Trumpet

Lilies are wonderful to paint because they have rich colors and diverse shapes. The initial cone shape opens out like a trumpet. Use the brush delicately when applying the paint.

O Start with a wash of Indian Yellow and Cadmium Orange, allowing the colors to mix on the paper to form the base of the lily. Flood into a triangular shape.

Using a green made from Indian Yellow and French Ultramarine, flood a little into the base of the lily while it is still wet and continue down to form the stem. Start with blobs of a pale wash of Permanent Mauve to create the petals.

Yellow

Cadmium Orange

French Ultramarine

Permanent Mauve

Cadmium Red

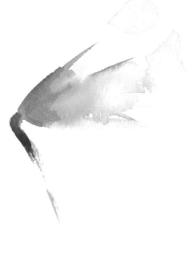

Finish the blobs of Permanent Mauve to show the span of petals. While still wet, paint in the stamens with Cadmium Red. Load the brush with Cadmium Orange and delicately, but directly, use the point to add in the striations on the petals. Add a little Cadmium Orange to the green to give a variety of tone in the stem.

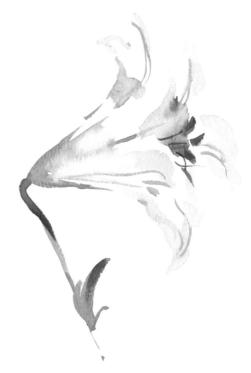

Irises that are moved by a gentle summer breeze often appear to be flying. They have a lovely variety of colors and their petals resemble wings.

Ceruleum

• Using Ceruleum, brush in the shape of the upper petals, then articulate the edges with some strokes of Permanent Mauve to create a sense of form.

Permanent Mauve

Cadmium Yellow

Cadmium Red

Using more of the same colors, indicate the outer edges of the main petal and add a little more Permanent Mauve to the upper petals.

This is the petals by continuing in the same way, then paint the center of the main petal in Cadmium Yellow, dropping in Cadmium Red while it is still wet.

Using color

To reproduce the amazing colors of flowers, you need a basic understanding of color theory. Your choice of color combinations and their relative intensities is vital. For a bank of flowers of the same color, it is exciting to explore the subtle differences of hue, whereas complementary colors, such as reds and greens, create drama and complexity.

Color wheel

This color wheel demonstrates the relationships between the colors.

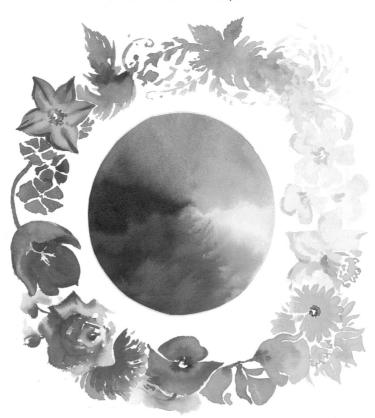

▲ Colors that are side by side, such as orange and yellow or blue and green, are called harmonizing.

Colors that are directly opposite one another, such as purple and yellow, are complementary.

Colors with one other color in between, such as green and orange or yellow and blue, are called contrasting. A thorough understanding of color relationships will greatly increase your confidence when you are using different colors.

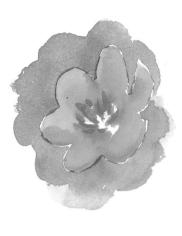

▶ Harmonizing (yellow and green)

▲ Complementary (blue and orange)

▶ Contrasting (purple and green)

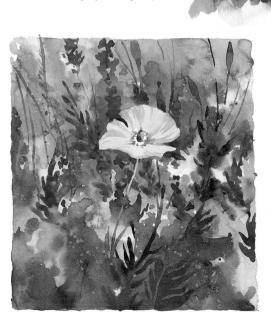

◀ In a field of yellow sweet corn, a single poppy reigns supreme; it becomes the focus of attention. This is what is known as the oddman-out principle. You can use this color device in many different ways to draw in the viewer's eye or encourage it to move throughout a painting. Even with dramatic color this principle works, as you can see in this painting of a poppy.

Seasonal colors

It is possible to use similar colors but to create a different mood or atmosphere by using them in different proportions. For example, in the painting of spring, the yellows dominate and create a feeling of freshness, whereas in summer the warm blues and hot reds give a sense of heat.

Spring

Keep your colors fresh and clean and vary the yellows to create a natural effect.

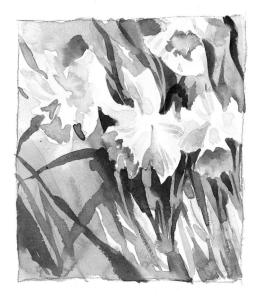

Summer

Permanent Mauve

In order to create a summer feeling, use warm blues and reds applied softly.

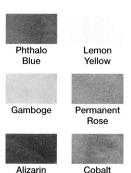

Blue

Crimson

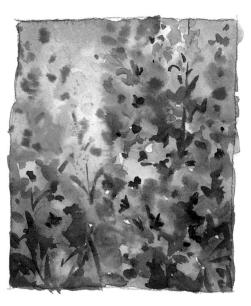

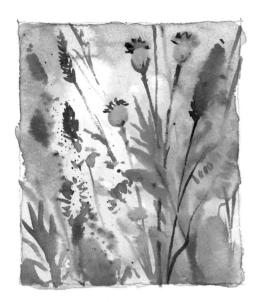

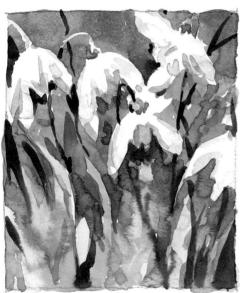

Fall

A chance to practice your color mixes so that the golden and burnt colors sing.

Cobalt Blue

Permanent Rose

Indian Yellow

Cadmium Orange

Alizarin Crimson

Winter

Cool colors and a large proportion of blue will help produce that wintry feeling.

Alizarin Crimson

140

Discover Watercolor

White flowers

To create the whitest areas when painting in watercolors, leave the paper showing—how much white you leave is crucial. The subtle colors you pick for shadows, or to mark out petals, need careful consideration. Try to see shadows and forms as abstract shapes; how they form the is the key.

▶ White rose

The amount of unpainted paper is at least 50 percent of the total flower shape. Use subtle color variations in the folds and petals. Of course nothing in nature is completely white because it reflects color from all around, so use a little of the background color in the flower.

▼ White lilies

Here, start by painting the centers and allow them to merge with the shadows of the petals. Then paint the background, taking care to trap the shapes and help to bring the white areas forward. This is simple but effective.

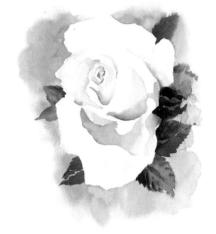

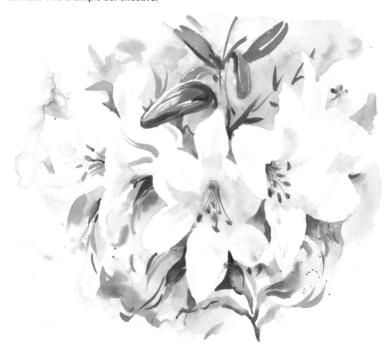

Leaves and massed areas of foliage are necessary and important features in most flower paintings. The addition of a leaf or two should complement your flower shapes. A variety of different greens should be used. It is best to mix your own greens rather than use ready-mixed; below are examples of various mixed greens.

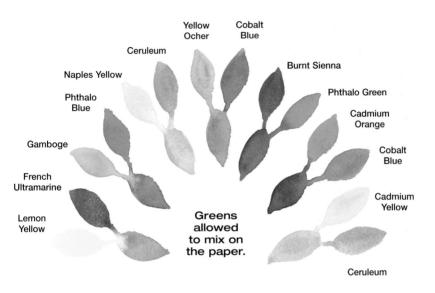

Useful dark greens, mixed thoroughly in the palette.

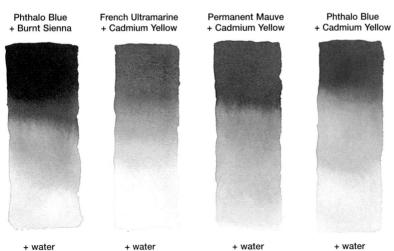

Creating form

Without shadows your flowers will look flat. Light against dark shows shape and form, and makes your flowers look threedimensional. The wonderful thing about watercolor is that it is transparent, making it an ideal medium for painting shadows, because the original colors show through the shadow color.

Peony

Color and shadow should not oppose one another but work in unison; remember that there are also colors evident in the shadows.

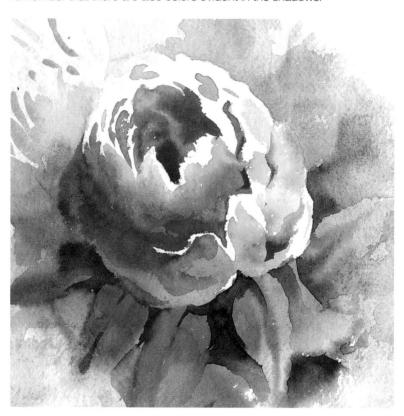

▲ The peony has a dark and a light side, an inside and an outside. Establishing these areas gives your flower form. Use Cobalt Blue on the shadow side and leave the white of the paper to act as the light side. Dark Alizarin Crimson for the inside helps to draw the eye toward the center of the peony.

This rose with its simple shape is a joy to paint. Large loose washes of purple can be painted over areas of the painting when dry to create shadows.

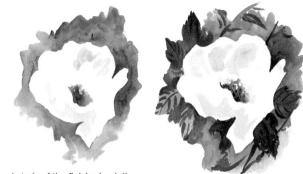

▲ This three-stage tonal study of the finished painting below enables you to see the development of light and dark without the complication of color.

dark areas have been identified.

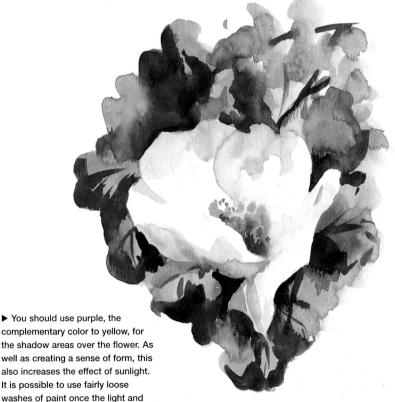

143

EXERCISE Paint a tulip

Using shadow is the main way to describe form in your paintings. In this painting of a tulip, start with the shadow areas and, as you can see, these will form their own shape. Use your No. 8 brush for this exercise.

The palette

Blue

Burnt Sienna

Phthalo Blue

Lemon Yellow

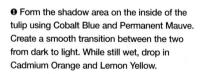

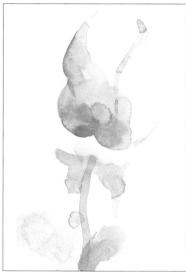

Put in two or three divisions for the petals using Permanent Mauve. Then work pale mixes of Phthalo Blue and Lemon Yellow for the stem and background.

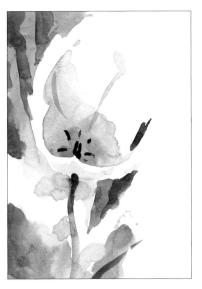

1 In this stage, you are promoting the light and dark in the background. Gradually show the outline shape of the tulip as you work. Put in the center stamens with a mix of Burnt Sienna and Phthalo Blue.

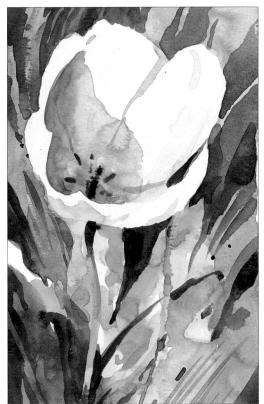

Freely block in the rest of the background with variegated washes using mixes of Cobalt Blue, Lemon Yellow and Phthalo Blue. Add dark mixes of Permanent Mauve and Phthalo Blue for the negative shapes of the foliage. Finally, run in some graded Cobalt Blue to the original shadow to enhance the form.

Flower features

When painting flowers you should consider their details, such as petals, buds, seed pods, and leaves, as well as their texture, such as whether they are soft or prickly. Just look around you and you will find astonishing diversity. All the exercises in this section are painted with a No. 8 brush.

Petal

No two petals are the same, so this example will need to be varied when you put different petals together to paint a whole flower.

Rose

• Paint the basic shape of the petal with Ceruleum and Permanent Rose, making sure that you paint in the serrations along the lower edge as you go.

A darker concentration of your previous mix of purple wet-in-wet is used for the darker pattern; feed it in with the tip of your brush.

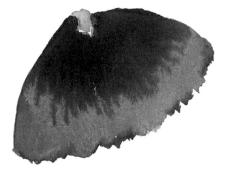

9 Paint in the striations and darken the edge of the petal. Drop in a little Cadmium Orange mixed with Cadmium Yellow to indicate the center.

Bud

All flowers have buds of different shapes, sizes, and colors. Here, a rose bud has been chosen for you to practice. Study buds carefully and paint as many different types as you can so that you will have them for reference when painting more complex pictures later.

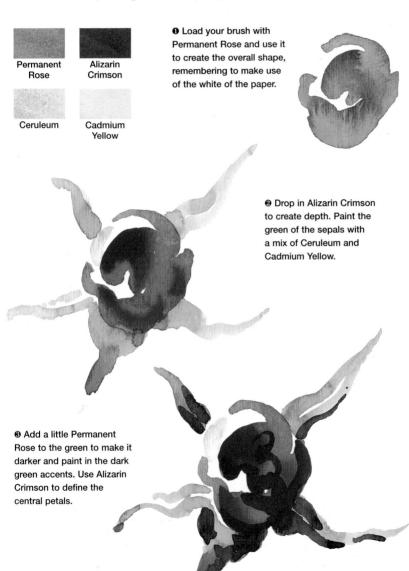

Discover Watercolor

Seed pod

There is tremendous variety in the different seed pods and heads of flowers. Although the shapes can look complex, it is possible to simplify them. Try painting this simple poppy seed pod.

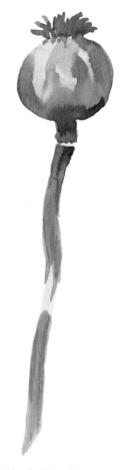

• Paint the basic lollipop shape in with Ceruleum. Add the stem with a single stroke of the brush.

Then add a darker concentration of Ceruleum with a touch of Cadmium Yellow while still wet to create the form.

Use Cadmium Orange and a touch of Burnt Sienna to paint the spiky top of the seed pod and flood a little into the base of the pod. Add darker definition to the stem.

Ceruleum

Cadmium Orange

Sienna

Whether you live in the town or country you are surrounded by different types of leaves. Try to handle the shapes as simply as possible. This whole exercise is painted quickly wet-in-wet (see page 17).

- Paint in a basic leaf shape with simple brushstrokes using Cadmium Yellow. Drop in Cobalt Blue and allow to mix.
- Add a little Burnt Sienna to articulate the serrated edge on the left of the leaf.
- Ocontinue with Burnt Sienna on the right-hand side and paint in the veins and stem of the leaf.

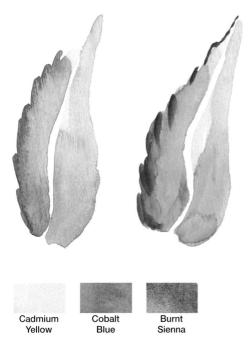

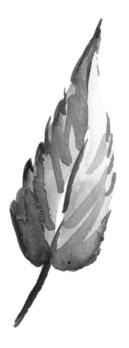

MUST KNOW

Painting leaves

When painting a new leaf, study it carefully and determine the overall shape. Then pay attention to the divisions and color variations. Even when leaves are from the same plant there is diversity, so remember this when you are painting and don't paint them all the same. Be aware that what you are aiming for is an impression of a leaf, or group of leaves, not a botanical illustration.

EXERCISE

Paint an oriental poppy

Oriental poppies have a lovely simple shape with easily recognizable features. Here, this simple view includes the features both inside and outside the flower. Once you get the basic elements in place you can have a great deal of fun with the rest.

The palette

nt

Sienna

Cadmium Yellow

Burnt Sienna

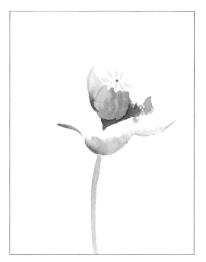

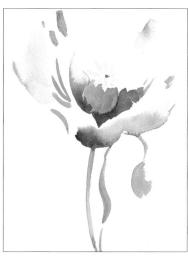

@ Extend the washes of Permanent Rose, dropping in Alizarin Crimson to form the petals. Try to use single strokes of the brush because this creates a transparent, clean effect. Using your green mix, add the bud. These tend to hang over, whereas seed heads stand up straight. Always try to reflect nature in your flower paintings.

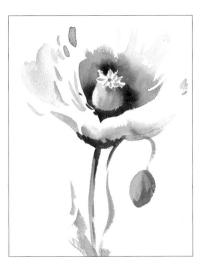

❸ To create more form, begin to bring in darker tones both inside and out. Use French Ultramarine with Alizarin Crimson around the center and to the base of the poppy, plus a stroke of French Ultramarine at the top of the stem where a shadow would be cast. Complete the bud with some cool mixes of Ceruleum and Raw Sienna, and begin a leaf at the base with a few strokes of the brush.

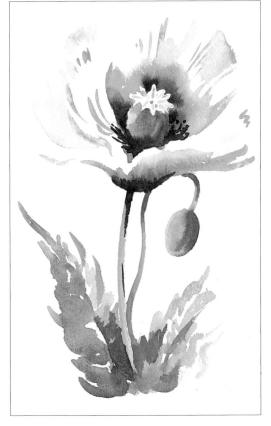

Foliage

Foliage is often only considered as an afterthought in a flower painting, but it should be an integral part of the whole painting. Leaf shapes and massed areas of foliage can be exciting and diverse, and they add life and depth to your paintings. This section suggests a few different ways you can explore painting leaves and foliage.

Leaves

Painting a leaf in full detail and with equal attention can make your painting look fussy and can detract from your flower forms. Remember that the angles of leaves and stems are important to the overall design and should not be overworked. Large sweeps of the brush can do a lot to create the impression of leaves, so keep details, such as veins, to a minimum.

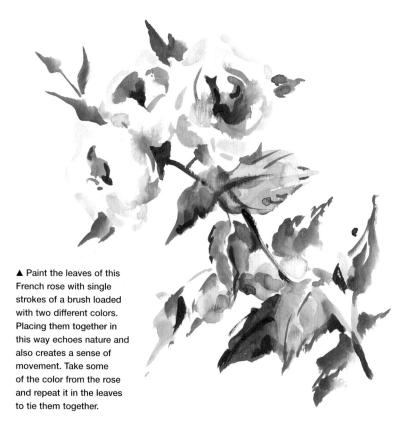

Leaf shapes

These leaves range from blue to almost brown. It is important to vary the colors, sizes, shapes, and ways of rendering your leaves. Ask yourself what the basic colors are, then explore as many as you can.

▼ All these leaves are from different flowers; see how the shapes, colors, and textures change.

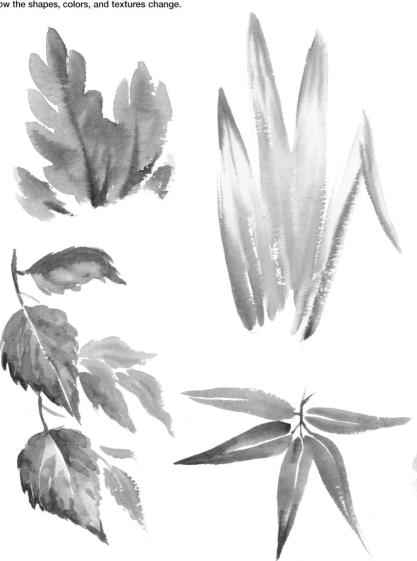

Massed foliage

If you start with amorphous shapes, you can add definition later on. Keep an eye on the overall effect. Cover all the large areas first, then return to add details; this will help to keep your washes fresh and flowing.

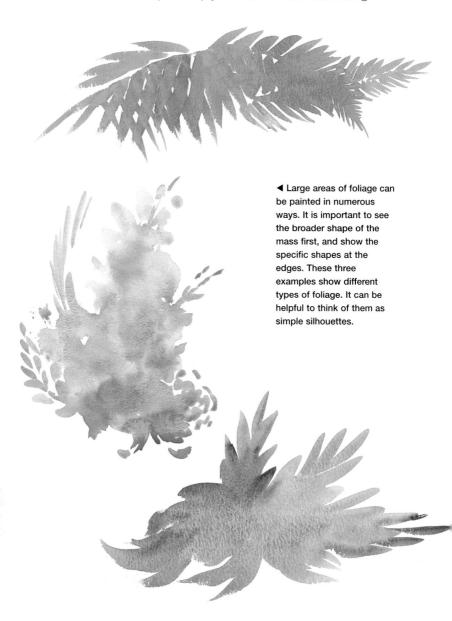

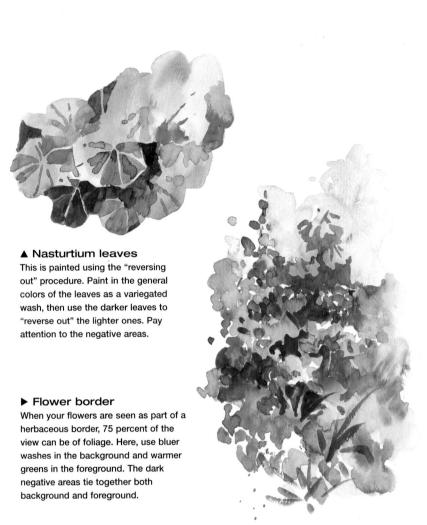

MUST KNOW

Painting massed foliage

A simple way to approach massed foliage is to start painting from the general to the particular; for example, first paint in the overall shape, then add in the subdivisions and details. It is important to remember only to add those details that are necessary. If you paint the details first, you will find yourself trying to protect them, and this will make the whole exercise far more difficult and can even result in an overall lack of cohesion.

Composition

Composition or design is the term applied to how your painting is arranged, or, in this case, where you place your flowers within the space. It refers to the elements you place within the format. The format is the window area that you are painting on. Many formats are possible, but most often the format is rectangular or square and either horizontal or vertical.

Movement

Composition can create a sense of movement and can give you confidence with the placement of your flower shapes and foliage. Its main aim is to provide you with more freedom of execution.

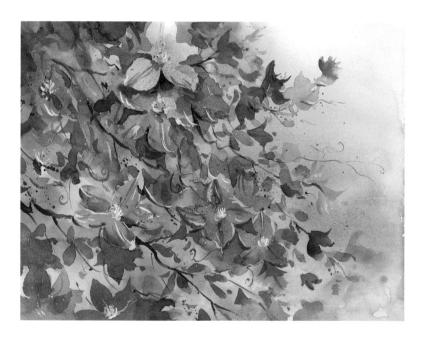

▲ In this painting of purple clematis, a horizontal format was chosen and a diagonal line of movement was used to pivot the flower shapes and foliage. Making decisions such as these at the beginning will provide the opportunity for greater freedom of expression.

Thumbnail sketches

The benefit of a simple thumbnail sketch is that it provides you with a plan to follow. Here are some simple ones that you can practice.

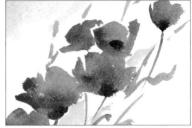

▲ Diagonal

Start by placing the main shapes of the flower heads in a diagonal composition, then build the painting outward from there.

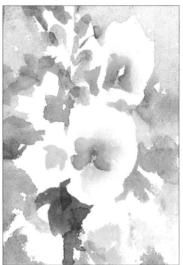

▲ Off center

Place the buds and foliage slightly left of center and add in the flowers to achieve an off-center composition and again continue outward. Here, dropping in a simple blue wash pushes the pale flowers forward.

Focal point

As well as a strong composition, you will also need a focal point. This is the area of interest in a painting that draws the viewer's eye. A useful tip is to place the focal point at an unequal distance from all four sides of the painting.

Here, you can see a thumbnail sketch and a more finished painting showing a triangular composition, which helps to lead your eye to the focal point, the main daisy.

Relative sizes

It is important to vary the relative sizes of the flowers within your painting in order to create interest. For example, it is useful to include large, medium, and small shapes; you may find it helpful to remember this as the "daddy, mommy, baby" principle.

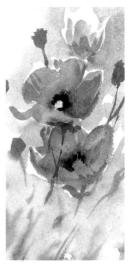

• With your No. 8 brush, paint in the overall shape of three pink oriental poppies using Alizarin Crimson, and, while still wet, brush in a little Permanent Mauve. Remember the "daddy, mommy, baby" principle.

Using a green made from Ceruleum mixed with a little Yellow Ocher, add in the cups beneath the flowers and the stems. With the same colors, but predominantly Ceruleum, start to add in a simple wash background.

Add in a few more stems and poppy heads with a darker mix of your green, then complete this simple painting by finishing the background wash using a variety of the colors already used in the painting.

Alizarin Crimson

Ocher

EXERCISE Paint carnations

In this study of carnations, keep the basic shapes of each flower simple. Concentrate more on the design in the initial stages, using the background colors to push the lighter forms forward in the final stage.

The palette

Permanen Rose

Alizarin Crimson

Lemon Yellow

French Ultramarine

Ceruleum

Cobalt Blue

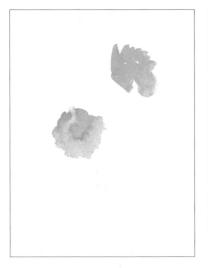

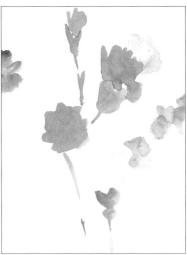

● Flesh out more of the design by working rapidly toward the edges of the paper; this will give you a quick grasp of the overall design. Use Ceruleum and Lemon Yellow to create the greens.

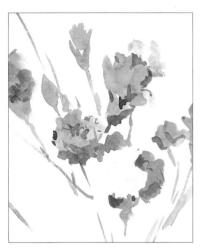

9 Add in some darks at this stage to create some form on the flowers with washes of Alizarin Crimson; use French Ultramarine for the foliage. Keep adding stems as you feel the design growing.

9 When you feel you have enough flower heads placed, start adding background washes around them with Cobalt Blue, Lemon Yellow, and Permanent Rose in variegated form. Finally, add some wet-in-wet carnations to the bottom left-hand side of the painting.

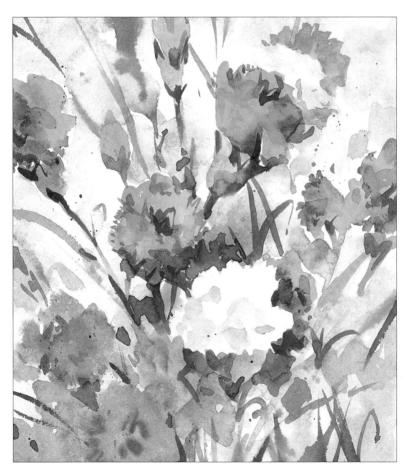

Garden flowers

You will find inspiration in any garden bed; shapes and colors are always amassed to give the artist a wealth of riches to draw upon. You can grow the flowers that you like to paint in your garden. There are also many gardens that are open to the public where you are often welcome to paint.

Pansy

Pansies have plenty of movement in them, as well as rich colors and texture. Their light and dark patterns are an added bonus for an artist.

Take your No. 8 brush and place Cadmium Red and Cadmium Yellow in the center of the paper, working out with a skirt of purple made from Cadmium Red and French Ultramarine Begin to indicate the petals with small washes of Naples Yellow; let dry.

@ Paint a wash in the negative areas of the background. The greens are a free mix of Cadmium Yellow, Ceruleum, French Ultramarine, and Cadmium Orange. Place washes of Permanent Mauve for the shadow areas on the flower. Strengthen the dark center.

Red

Ceruleum

Cadmium Orange

Permanent Mauve

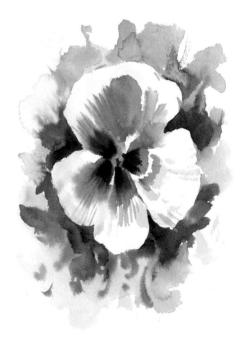

Daisy

A common mistake when painting daisies in watercolor is not to leave enough white paper showing for the petals. This exercise avoids this error by painting in the background last of all.

• Paint in the central ellipse with your No. 8 brush and dilutions of Gamboge. Cadmium Orange, and Burnt Sienna, Allow them to mix on the paper as much as possible.

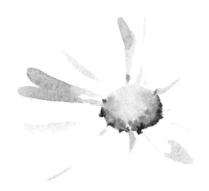

9 Indicate a few of the shadows on the petals with an even mix of Ceruleum and Permanent Rose. Take care not to make them all the same. Strengthen the Burnt Sienna around the edge of the center.

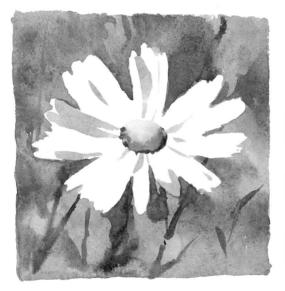

Mix washes of Cadmium Yellow, French Ultramarine. and Ceruleum in various combinations before you start. Paint in a variegated wash, dropping in darks with French Ultramarine, and be careful to paint around the petals.

Gamboge

Cadmium Orange

Burnt Ceruleum Sienna

Permanent Rose

French Ultramarine

Rose

The lovely, silky petals of roses help make them one of the most complete flowers, and they represent a wholeness of form and color, making them a sheer joy for any flower artist to paint.

Burnt

Red

Yellow

Sienna

Ceruleum

Cobalt Blue

O Using your No. 14 brush, put down a wash of Indian Yellow to form the center, then soften the edges with some water and a little

Cadmium Red to create the

outer petals. Let it dry.

@ Paint a loose wash of Cobalt Blue to form the outer shape. While still damp, start to add leaves made from mixes of Cobalt Blue and Indian Yellow. Develop the rose with your No. 8 brush using Indian Yellow and Cadmium Red.

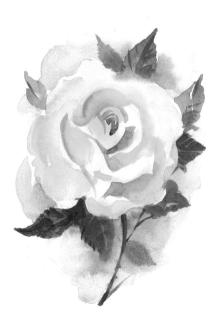

Work from the center of the rose outward with smaller shapes, at first using more concentrated color to form the petals. Soften the edges with water as you go along. Put a wash of Cobalt Blue around the outside and then add some leaves and details of veining.

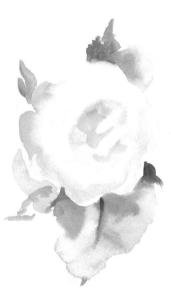

The exotic-looking camellia belongs to a group of plants that includes the tea plant. The dark green glossy leaves create a dynamic contrast with the delicate petals, making it enjoyable to paint.

O Using your No. 8 brush, paint the center with Cadmium Orange and Lemon Yellow, Start some of the divisions on the petals with a mix of Permanent Rose and French Ultramarine.

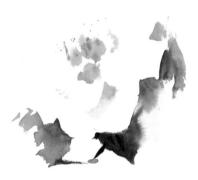

Add further divisions of petals, then establish the outside shape with foliage using varying mixes of Phthalo Blue, Cadmium Red, and Lemon Yellow.

Orange

Yellow

French Ultramarine

Phthalo Blue

Rose

Indian

Yellow

Burnt

Permanent Mauve

Sienna

Finish articulating the leaves, then add further details to the petals. Drop in a variegated background wash using Indian Yellow, Permanent Mauve, and Cadmium Red. When dry, splash Cadmium Orange and Burnt Sienna across the center to represent the seeds.

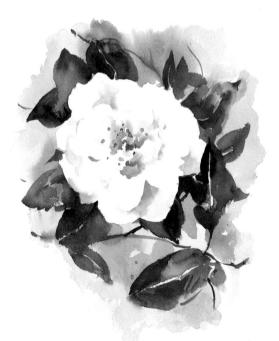

Delphiniums

Although delphiniums are complex, you should simplify their overall shapes when you paint them. Treat a flower initially as a blob of paint, adding any necessary detail at a later stage.

• With your No. 14 brush, mass in the overall shapes using Ceruleum and Permanent Mauve, Let these colors mix freely together on the paper.

Permanent Mauve

French Ultramarine

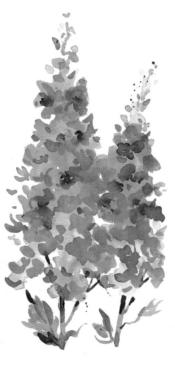

- Ontinue painting the mass shapes, then some strong greens (Ceruleum with Cadmium Yellow) to form the stalks and the leaves of the plant.
- Start separating the forms by using darker mixes of Permanent Mauve and French Ultramarine, Articulate individual flowers and leaves with your No. 8 brush. Spatter some purples and dark greens onto this wash to create some additional texture.

Sunflowers

When you paint these sunflowers, use the exercise as a guide. Don't feel you need to follow it exactly, but try to create your own painting.

Cadmium Orange

Permanent Mauve

French Ultramarine

Cobalt Blue

Burnt Sienna

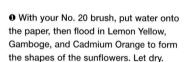

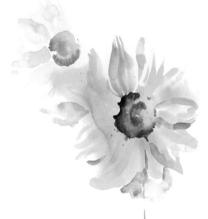

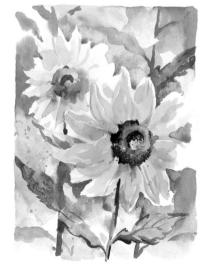

- O Using your No. 8 brush, paint the flower centers with Cadmium Orange and Permanent Mauve. Use a mix of Cadmium Orange and Gamboge for the petals, leaving some of the yellow showing through. Blush in some green (French Ultramarine, Gamboge, and Ceruleum).
- Use French Ultramarine and Lemon Yellow to paint the foliage in the negative spaces. Add Permanent Mauve to the background. Paint leaves and stems with single brushstrokes of two colors. A little Cobalt Blue adds depth to the foliage. Enhance the darks with Permanent Mauve and Burnt Sienna. Splash a dark mix of Lemon Yellow and French Ultramarine onto the foliage.

EXERCISE Paint a garden bed

In this painting, the daisies rely on a technique known as reversal, because you are painting around the subject and not the subject itself. It is useful to practice because it pushes the subject into relief.

The palette

French

French Ultramarine

Orange

Sienna

• Load your No. 6 brush with Cadmium Orange and place some of the centers of the daisies around the focal point of the picture. Don't crowd them too close together. Use Permanent Mauve for shadow areas, bringing out the suggestion of daisies right away. Drop Burnt Sienna into a couple of yellow centers.

With a wash of French
Ultramarine and Ceruleum
allowed to mix freely on
the paper, paint in the
background negative shape
to bring out the main clump
of daisies. Add a mix of
Ceruleum and Indian Yellow
to indicate some of the
foliage. Add some darker
blobs of Permanent Mauve
for the lavender and a few
more toward the bottom of
the painting.

Work on both the rightand left-hand sides, taking care to leave areas of white paper. Daisies should start appearing miraculously from the apparently random shapes. Use splashing to create some lavender heads.

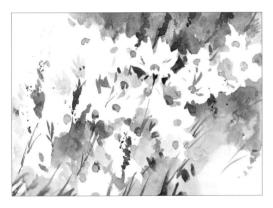

• Use a No. 10 brush to wash in greens made from varying mixes of Ceruleum, French Ultramarine, and Indian Yellow. You should try to connect the greens across the painting to ceate a sense of harmony. Use the tip of the brush for the sweeping lines of stems and leaves in single strokes, and use the body of the brush for larger wash areas.

→ Add a wash of Ceruleum
to the top left and pull it
through the shadow areas
down toward the greens
to tie the background in to
the subject. Paint in more
lavender with the splashing
technique and add some
further shadows from a mix
of French Ultramarine and
Permanent Rose.

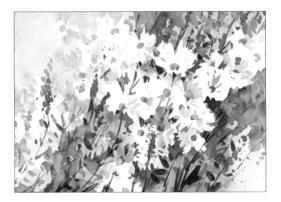

Wild flowers

Wild flowers are all around you, whether you live in the town or the country. They proliferate on roadsides, as well as in neglected corners of the garden. Once you start to look you will notice them everywhere. A grassy field filled with bluebells or a stray poppy is always a joy to paint.

Buttercups

Bright yellow buttercups with shiny petals are lovely to paint. This simple view of buttercups shows the beauty of loose handling and fresh colors.

• Take your No. 8 brush and Lemon Yellow and paint some buttercup shapes. They have five petals. Mix a fresh spring green using Ceruleum and Lemon Yellow and add the stems and leaves. Put in a touch of Burnt Sienna for extra coloration. Leave to dry.

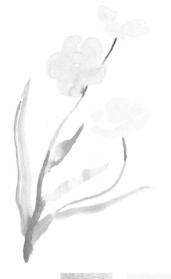

Ceruleum Lemon Yellow

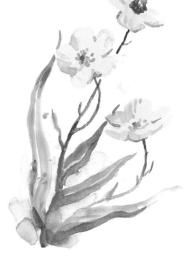

With your fresh green mix, paint in the center of the buttercups, adding a little French Ultramarine to the darker side.
 Using small stabs of a brush loaded with Cadmium Orange, paint into the green centers. Articulate the foliage.

Burnt Sienna

Cadmium Orange

Ultramarine

Field poppy

The red field poppy is surely the king of wild flowers. This exercise gives you a chance to use all the reds against a background of purple and cool greens.

Paint the basic poppy shape using Cadmium Red and Cadmium Orange. Use darker mixes of Permanent Rose and French Ultramarine for the center and stem.

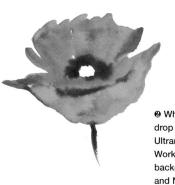

While the center is damp, drop in a dark mix of French Ultramarine and Burnt Sienna. Working quickly, block in the background with Ceruleum and Naples Yellow to form some foliage.

Cadmium Red

French

Ultramarine

Naples Yellow

Create the background details using stronger mixes of greens and purples. Try to keep the background wet-in-wet as much as possible. Paint the striations and divisions on the petals of the poppy.

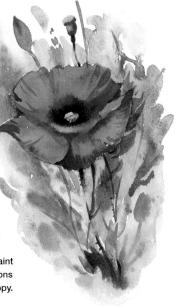

Bluebells

Bluebells, or harebells, are a delightful sight, emerging in clumps in grassy fields. A few fine days should allow you to get outside to paint them.

• With your No. 8 brush, use a mix of Cobalt Blue and Ceruleum to paint in some bell shapes.

eruleum Permane Rose

Cadmium

Cadmium Yellow

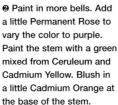

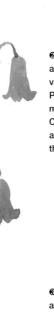

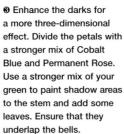

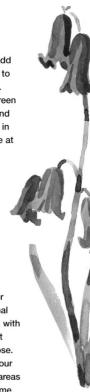

Forget-me-nots

Handle this spray of forget-me-nots simply and paint them straight onto the paper so there is nothing to interfere with the freshness of the colors.

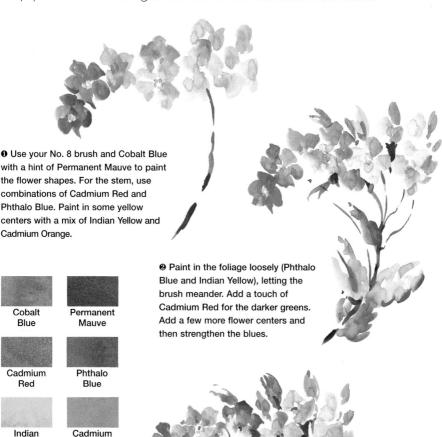

Put in the dark centers of the flowers using dots of Phthalo Blue and Cadmium Red. Separate the flowers with stronger concentrations of Cobalt Blue and Permanent Mauve. Some touches of Cadmium Orange on the centers help attract the eye. Finish the foliage by adding the darks.

Orange

Yellow

EXERCISE Meadow

In a wild flower meadow, there is a myriad of flowers of unusual colors and shapes, ensuring that there is always something interesting for you to paint. Take your sketchbook out into the fields on a warm sunny day.

The palette

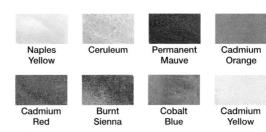

• With a No. 20 brush, paint a wash of Naples Yellow and Ceruleum. While wet, load your No. 8 brush with Cadmium Orange and Cadmium Red and splash onto the paper. Start the first poppy with a few brushstrokes of the same colors, allowing the colors to bleed. Let dry.

❷ With Cadmium Red and Cadmium Orange, add definition to the first poppy and paint the petals of the two main poppies. Place dots of Cadmium Yellow and patches of Permanent Mauve randomly across the paper. Drop in the center of the right-hand poppy (Permanent Mauve with a hint of Burnt Sienna). Leave to dry.

Add foliage using green (Ceruleum and Cadmium Yellow, more blue than yellow). The darker green is Cobalt Blue and Cadmium Yellow. Add in the petals of the foreground poppy. Do not add too much detail to the daisies. Place the yellow centers, then brush in the foliage around them to create some daisy shapes.

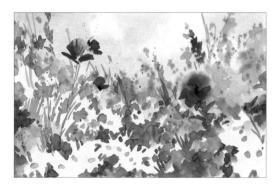

• Continue painting the broader areas of the flowers and foliage. Remember to vary the colors you are using. Add a little Burnt Sienna to the Cadmium Yellow in the foreground on the right. Suggest the daisies at the bottom right in a similar way to those in the previous stage.

② Start adding a few details here and there, but do not add too many; you want to create the tangled effect of a wild flower meadow. Paint in a few more grasses with single strokes of the brush. Finally, use a bit of splashing with Cobalt Blue and Permanent Mauve to give the effect of extra flowers.

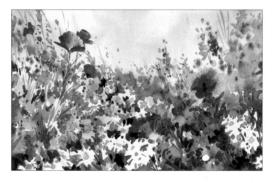

Backgrounds

How the background interacts with the subject of your painting is vitally important to the overall look, especially in flower painting. Consider the background as an integral part of the painting process, not merely as an afterthought. In this section, you will learn some different ways of approaching backgrounds in watercolor as an effective means of creating impact in your paintings.

Negative spaces

When you look at a simple group of flowers, the important thing to notice is the shape of the spaces between them. These are referred to as negative spaces and are an essential ingredient for painting backgrounds.

▶ In this painting of daffodils, lights and darks have been added to create drama. The negative spaces are complex but all the flower heads are a great deal lighter than the background tones.

MUST KNOW

Creating impact in your painting

Start off with a small division between two flowers—it will usually be triangular or diamond in shape—and then work outward from there. This will help give your painting immediate impact and cast the flowers forward.

Flowers first

If your subject matter is lighter than the background, see the background as a negative shape and paint around the flower shapes. In this exercise, it is easy to see the negative shapes of the background between the petals.

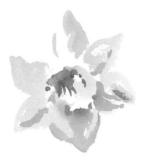

Gamboge

Cadmium Orange

Blue

Burnt Sienna

French Ultramarine

Permanent Mauve

• Using Gamboge and Cadmium Orange, paint a star shape with a No. 8 brush. Leave white paper showing as highlights. Loosely form the flower shape. While wet, drop in washes of Cadmium Orange and Burnt Sienna to create the center and form on the petals.

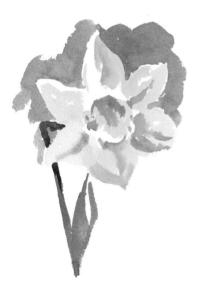

Paint some single strokes of green (French Ultramarine and Gamboge) to represent a stem and a leaf. Make the petal overlap the stem. When dry, mix a flat wash of purple, (Cobalt Blue and Permanent Mauve) and paint the negative space.

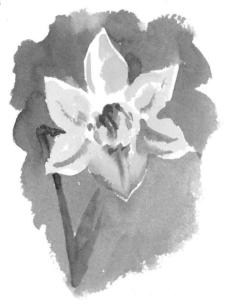

Continue your purple wash until a background forms and brings the flower forward. Enhance the center with a few well-chosen darks. This exercise is a simple procedure and should be practiced until you feel confident with the process.

Background first

If your subject matter is darker than the background, it is possible to paint the background first then place the flowers on top. Remember to allow the background to dry before you start painting over the top.

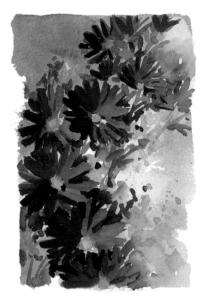

• Use your No. 8 brush to paint a variegated wash of Cobalt Blue, Permanent Mauve, and Naples Yellow to contrast with the red of the chrysanthemums. You should try to keep your color washes the same consistency as one another. Allow to dry.

Paint the flowers in Cadmium Red and Alizarin Crimson directly onto the blue-allow some show through. Add the foliage with varying mixes of Cadmium Orange, French Ultramarine, and Lemon Yellow. Drop in the flower centers with Cadmium Orange.

Permanent Mauve

Alizarin

Crimson

Cadmium Orange

French Ultramarine

Leaving white space

If the flowers are lighter than the background, you can still paint the background first by taking care to paint around them.

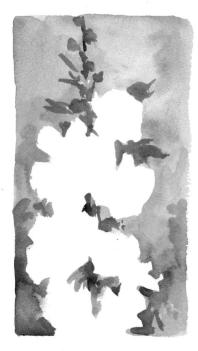

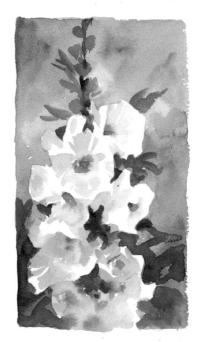

With the background complete you can see more clearly what is needed with the flowers. Start by painting the centers Lemon Yellow and Cadmium Orange, ensuring you leave enough white paper. Pale washes of Ultramarine Violet help create the shadow areas.

Ultramarine Violet

Ceruleum

Orange

MUST KNOW

Keep your colors flowing

When painting backgrounds first it is important to keep your colors flowing. Using the wet-in-wet technique will help to keep your background cohesive and create a much more satisfying setting for your flowers.

Jigsaw painting

In jigsaw painting, the parts, one piece at a time, fit into each other in any order you choose. This technique relies on the principle that the whole is greater than the sum of the individual parts. The idea is to slot the pieces together ad hoc and work quickly to create a sense of synchronicity.

- Start with the blues and pinks of the main flowers, keeping the shapes and colors abstract in form.
- Working outward, paint the negative shapes around the flowers with washes of Phthalo Blue, Burnt Sienna, and Gamboge. Place more flowers and foliage randomly.

Phthalo Blue

Burnt Sienna

Gamboge

Ceruleum

Vermilion

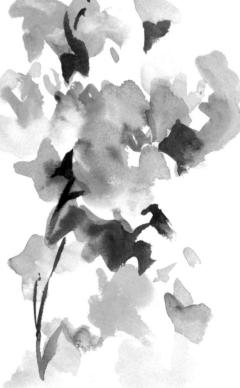

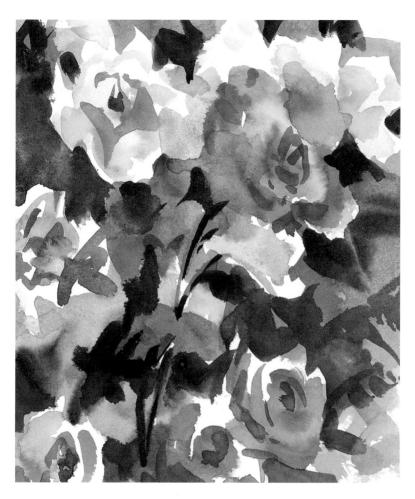

Ocntinuing with more of the same, put in smaller darks as accents in both flowers and background. Let your reactions take over and the painting will form itself.

MUST KNOW

Joining up the pieces

To paint in this way, it is essential to keep the jigsaw pieces next to one another. Join each piece of paint together with another. In other words, do not place patches disparately across the paper and hope that they will join up later. The whole painting needs to evolve naturally. It is an organic process and in a way you are mimicking the way in which flowers grow and develop in nature. The painting will literally grow in front of your eyes.

Flowers in containers

Painting flowers in containers can seem like a daunting task at first. What is a seemingly beautiful arrangement can become a painter's nightmare. A useful tip is to paint the flowers first and then add in the mass of foliage and pots around them. Remember that not everything needs to be clearly seen.

Geraniums

In the summer, pots of geraniums are a joy to paint. Their circular shapes and strong colors can seem complex at first; remember to simplify them.

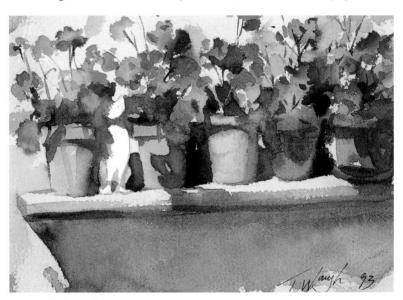

▲ This simple row of terracotta flowerpots filled with geraniums is in strong sunlight. The way the shadows and dark areas connect is vital to the painting's success.

MUST KNOW

Negative spaces

When painting flowers in containers, you should pay particular attention to the negative spaces—the spaces between the flowers and between the pots. This assists in an overall sense of depth.

By placing anemones in a clear vase. or even a basic jam jar, you can create an attractive subject to paint, and you will love the simplicity of its shape.

Permanent Rose

Cadmium Yellow

Phthalo Blue

Cadmium Orange

Ceruleum

Permanent Mauve

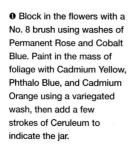

Paint the stems using a dry brush. Vary the colors of the stems. Work the forms of the flowers with darker washes and add in some extra flowers. Use dots of Naples Yellow in the centers of the flowers.

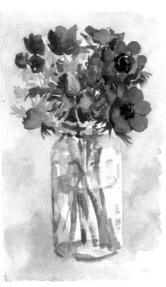

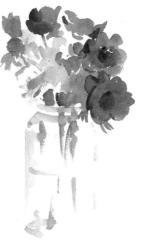

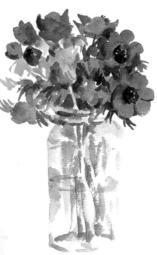

❸ When dry, you can add any smaller accents to the flowers and foliage that may be required. Use pale washes of Cadmium Orange. Permanent Mauve, Cobalt Blue, and Cadmium Yellow to paint in the background, starting top left and working down to bottom right. Take care to stop your wash at the edge of the jar to complete the right-hand side.

Discover Watercolor

Variety

As you look around, you will notice that all types of containers can be used for planting or displaying flowers, ranging from old tires, boats, and milk churns to the more usual vases and pots.

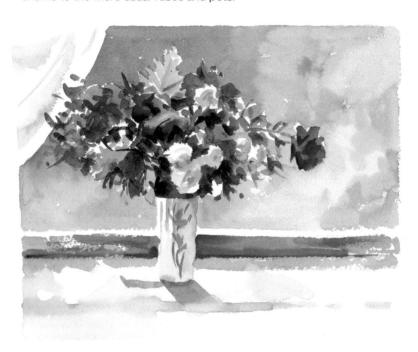

▲ The feeling of light in your paintings will enhance the view. The white of the paper is utilized here to represent the light hitting the subject.

▶ Make some small studies of container plants. There is something charming about red geraniums; they always seem to be so happy in their pots.

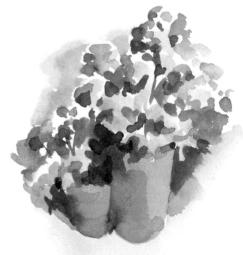

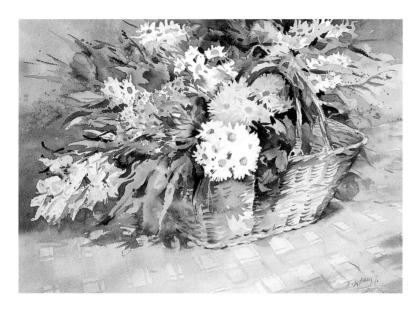

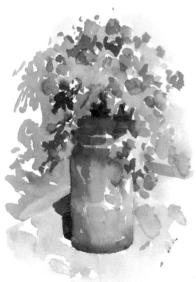

- ▲ Have fun picking and arranging summer flowers in a basket to show the abundance of the season and the sunlight that enlightens and illuminates ething.
- This rusty old milk churn made a great container for flowers to spill out and form their own designs and shadows.

MUST KNOW

Shadows

Look at how the shadows play an integral part between the flowers and their containers. The shadows are in recessed areas or cast by an external light source. These shadows create a three-dimensional effect.

Flowers in settings

Flowers are a constant reminder of the majesty of nature. Whether you witness an entire nation of poppies spreading their color over fields, or the first daffodil of spring, they stop you in your tracks and fill you with a sense of wonder. Try to make these personal glimpses of flowers and their settings inherent in your paintings.

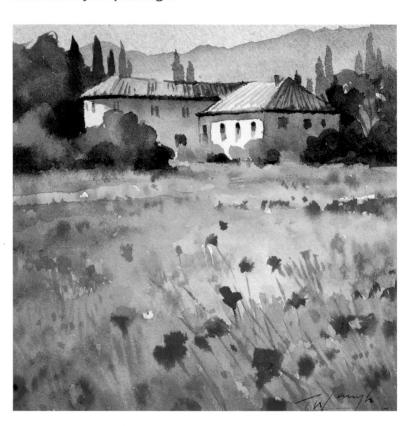

▲ Poppies in the South of France

7 x 7 inches (18 x 18 cm)
The poppies in this field were mainly painted wet-in-wet. The light on the typically Provençal farmhouse serves to enhance the colors.

▶ Val's Geraniums

10 x 8 inches (25.5 x 20 cm)

This painting provided the opportunity to study the light on pots of geraniums in a deeply recessed window setting. The quality of light is an important factor in creating a sense of time and place.

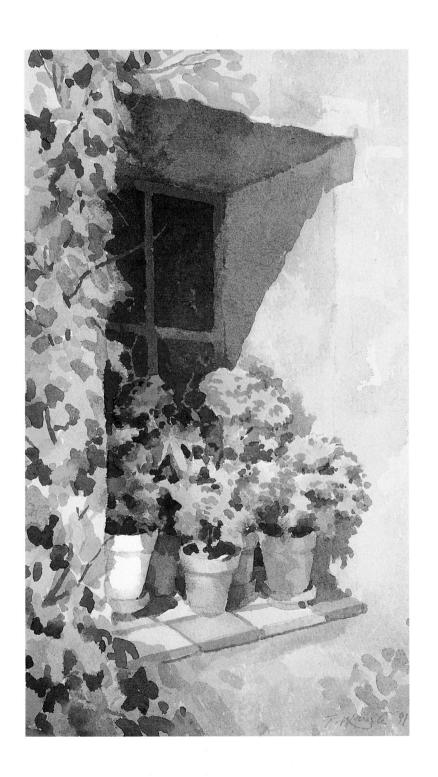

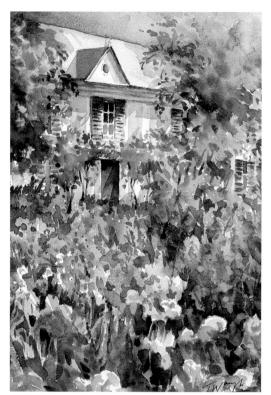

■ Monet's Garden 14 x 10 inches (35.5 x 25.5 cm) It is a real joy to paint in Monet's garden at Giverney in Northern France. The abundance of flowers and the arrangement of colors

give the watercolor artist so much inspiration.

▶ Nasturtiums

12 x 12 inches

(30.5 x 30.5 cm) This square format seemed appropriate for the diagonal arrangement of nasturtiums. The pot helps to offset the composition and provides a structure for this otherwise loosely painted design.

Trailing flowers and foliage enable you to explore movement and color.

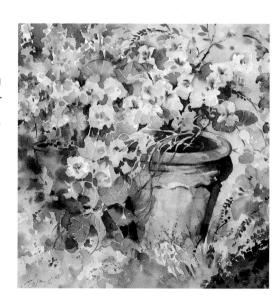

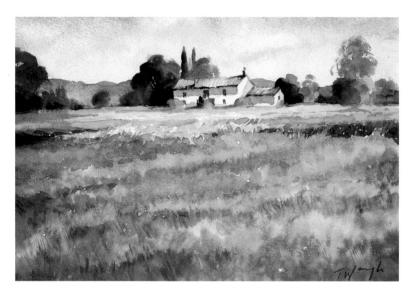

▲ Provençal Lavender

15 x 21 inches (38 x 53 cm)
The main objective in this painting was to show the effects of large clumps of lavender

spreading their color over the flat fields of Provence. Instead of concentrating on the individual flowers, they were together in swathes of soft color painted wet-in-wet.

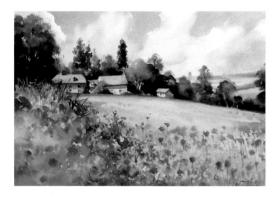

▲ Poppyfields at Great Barrington

14½ x 21 inches (37 x 53 cm)

This painting is of a landscape in the Cotswolds, England. The poppies add a splash of color to the foreground.

want to know more?

Take it to the next level...

Go to ...

- ► Easy color mixing: page 20
- ► Trees: page 36
- ► Shells and pebbles: page 84

Other sources

- **▶** Gardens
 - research new painting subjects
- ▶ Bookclubs
 - specialized clubs
- ▶ Art exhibitions
 - visit or even show your own work
- ► Local venues
 - may allow you to display/sell your work
- **▶** Publications

visit <u>www.harpercollins.com</u> for HarperCollins art books

Need to know more?

There is a wealth of further information available for artists, particularly if you have access to the internet. Listed below are just some of the organizations or resources that you might find useful to help you to develop your watercolor painting.

Museums

Smithsonian American Art Museum www.americanart.si.edu

Smithsonian National Portrait Gallery www.npg.si.edu

Metropolitan Museum of Art 1000 Fifth Avenue New York, New York 10028 www.metmuseum.ora

Magazines

The Artist's Magazine 4700 E. Galbraith Rd. Cincinnati, OH 45236 www.artistsmagazine.com

American Artist 770 Broadway New York, NY 10003 www.myamericanartist.com

Art Supplies

Daler-Rowney USA 2 Corporate Drive Cranbury, New Jersey 08512 www.daler-rowney.com

Faber-Castell USA, Inc. 9450 Allen Drive Cleveland, Ohio 44125 www.faber-castellusa.com

Mohawk Paper Mills, Inc. PO Box 497 Cohoes, New York 12047 www.mohawkpaper.com

Pentel of America Corporate Headquarters 2805 Columbia Street Torrance, CA 90509 www.pentel.com

Art Societies

The National Watercolor Society 915 S. Pacific Avenue San Pedro, CA 90509 www.nws-online.org

American Watercolor Society 47 Fifth Avenue New York, New York 10003 www.nws-online.org

Online Resources

Art Museum Network
The official site of the world's leading art museums.
www.amn.org

The Artlist Extensive listings of art shows, juried competitions, and contests etc.

www.theartlist.com

Interactive art club run by the Artist's Publishing Company.
www.painters-online.com

WetCanvas

This is part magazine, part virtual classroom, and part reference site. It is the largest community site on the internet with a specific focus on the practicing visual artist. It concentrates on providing the following services to visitors and members:

- A virtual community where artists can share ideas, critiques, and other information
- Tools for managing and promoting virtual/online galleries of work
- A complete array of art lessons and tutorials for all levels of artists
- Product comparison and research information for art supplies and services
- An image library www.wetcanvas.com

anemones 183, 183 animals 66-71, 66-71

backgrounds 176–181 beach 108–115, 108–115 birds 104–107, 104–107 blotting 33, 33, 82, 82 bluebells 172, 172 boats 122–125, 122–125 brushstrokes14, 14, 128–129, 128–129 brushes 10, 14, 129 buds 147, 147 buildings 47, 72–76, 72–76, 111, 111 buttercups 170, 170

camellias 165, 165 carnations 160-161. 160-161 cliffs 100-101, 100-101 clouds 29, 29, 30, 30, 32, 32, 33, 33, 82 color graded wash 16, 16 color mixing 20-23, 20-23 color wheel 136 colors 10, 136-141, 136-141 complementary 136, 137 contrasting 136, 137 cool 44, 45, 46, 48 greens 141, 141 harmonizing 136, 137 landscape 22-23, 22 - 23seasonal 138-139, 138-139 warm 44, 46, 48 composition 156-161, 156-161 cows 66, 66, 68, 68,

daisies 131, *131*, 163, *163*, *168*–*169*delphiniums 166, *166*distance 44–49, *44–49*, 108
drawing 12, 13

70-71

dry brush 15, 15, 49, 101, 129, 129

erasers 11

flat wash 16, 16 flower shapes 130–135, 130–135 flowers 126–189 focal point 158 foliage 152–155, 152–155 foreground 48, 49, 58, 58 forget-me-nots 173, 173

geraniums 182, 182, 186 graded wash 16, 16

irises 135, 135

jigsaw painting 180–181, 180–181

landscapes 26–77 leaves 128, 128, 141, 149, 149, 152–153, 152–153, 155 lifting 19, 19, 33, 33, 60, 95 lilies 134, 134, 140

marine life 90–93, 90–93 mist 46, 46, 60, 60 mountains 58–61, 58–61

nasturtiums 188 negative spaces 176, 182

paints 10 palettes 11 pansies 162, 162 paper 11 pebbles 85, 85, 88-89, 88-89, 109, 109 pencils 11, 12-13, 29 peonies 142, 142 people 62-65, 62-65, 116-121, 116-121 petals 146, 146 photographs 58, 65, 121 ponies 69, 69 poppies 130, 130, 137, 148, 148, 150-151, 150-151, 159, 171, 171, 186, 189

reflections 50, 50, 51, 51, 53, 54–55, 54–55, 94

rigger 14, 14, 37, 81, 81 rocks 102–103, 102–103 roses 133, 140, 143, 143, 152, 164, 164

sea 94-99, 94-99, 116 seascapes 78-125 seed pods 148, 148 shadows 24-25, 24-25. 72, 72, 73, 83, 83, 142, 144, 144-145, 185 sheep 67, 67 shells 84, 84, 86-87, 86-87, 88-89, 88-89 sketching 40-41, 40-41, 58, 63, 63-65, 76, 76-77, 87, 87, 107, 107, 112, 112-113, 120, 120-121, 124, 124-125, 157, 157 skies 28-35, 28-35 snow 56-57, 56-57, 61, 61 soft edges 18, 18, 129, 129 splashing and spattering 129, 129 sunflowers 167, 167 sunsets 31, 31

techniques 12–19, 80–83 blotting 82, 82 dry brush 80, 80 lifting 19, 19 soft edges 18, 18 wet-on-dry 18, 18 wet-in-wet 17, 17 washes 16, 16 three-dimensional objects 24–25, 24–25, 72, 83 trees 36–43, 36–43 tulips 144–145, 144–145

water 50–55, 50–55 waves 82, 94, 95, 95, 97, 97 wet-on-dry 18, 18 wet-in-wet 17, 17, 28, 29, 29, 32, 32, 34, 35, 49, 97, 100 wild flowers 170–175, 170–175,

washes 16, 16

INDEX